Triumph Books and colophon are registered
trademarks of Random House, Inc.

This book is available in quantity at special discounts for your group
or organization. For further information, contact:

Triumph Books
542 South Dearborn Street
Suite 750
Chicago, Illinois 60605
(312) 939-3330
Fax (312) 663-3557
www.triumphbooks.com

Printed in United States of America
ISBN: 978-1-60078-348-7

Photos courtesy of Getty Images except where otherwise noted

Content packaged by Mojo Media, Inc.
Joe Funk: Editor
Jason Hinman: Creative Director

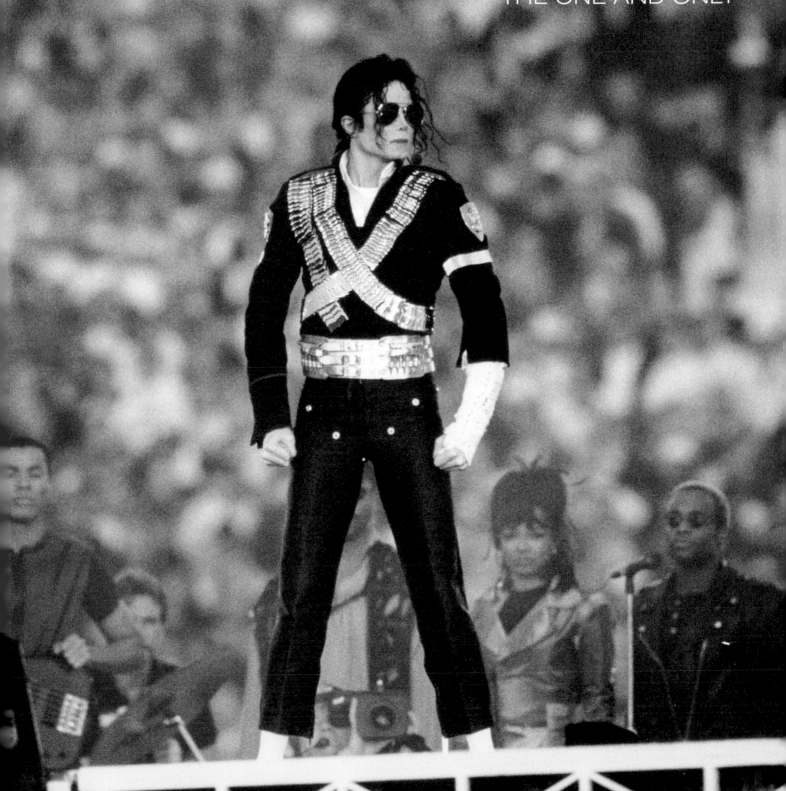

A TRIBUTE TO AN AMERICAN ICON

Michael Jackson

THE ONE AND ONLY

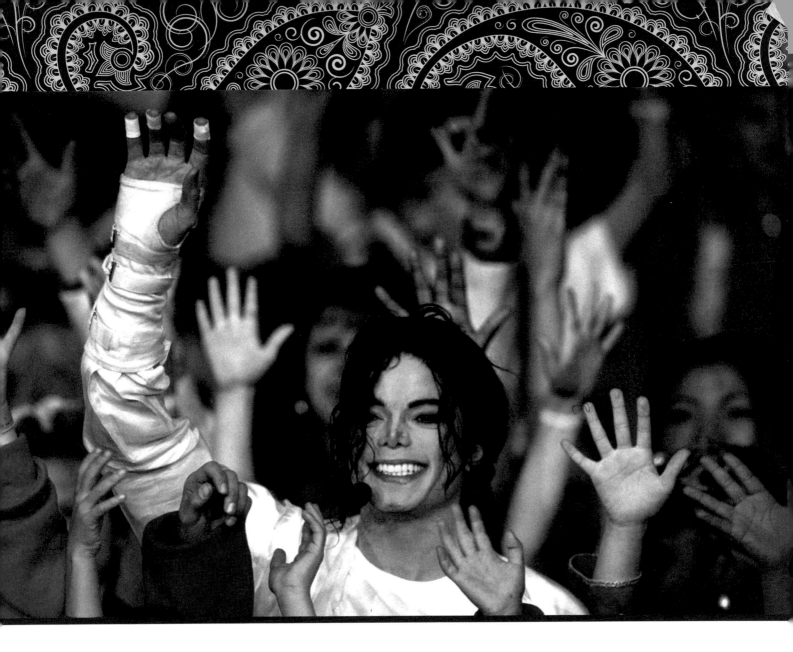

contents

The Day the
Music Died

(opposite) The news of Jackson's death reverberated quickly throughout the world. English- language Indian newspapers are stacked here with Jackson's death featured as the number-one news story. The scene was similar around the world, with media struggling to keep up with the demand for new information.

It all happened so suddenly. In the span of an afternoon, Michael Jackson was dead. It was news no one had expected. Although for years fans and foes had become ready for anything when it came to outlandish reports about Michael Jackson, they never thought they'd be hearing such definitive news, so soon.

Ready to launch his comeback after years of avoiding the spotlight and crushing scrutiny, Michael appeared ready to start the latest chapter in the book of his life with vim and vigor, not authoring his final cut.

The rumblings started around lunch time in Jackson's adopted hometown of Los Angeles. Reports started to trickle in that Jackson had collapsed and been rushed to the hospital, but there were no other details forthcoming. As the afternoon wore on, the news got worse. Word came that Jackson was unresponsive, but fans remained optimistic as they gathered near the singer's rental home and the UCLA Medical Center, certain that Jackson would bounce back because, at 50, he was still relatively young.

A vigil soon formed as it soon became clear Jackson was in serious trouble and fighting for his life. Jackson's family was at the hospital, and his father Joe told the media they were aware of Michael's health problems.

The worst fears soon became a reality—Jackson was pronounced dead after an hour of resuscitative efforts failed to revive him. He was pronounced dead at 2:26 PM Pacific Time. The cause of death was quickly announced as cardiac arrest, but the full story of what really happened to the singer may not be known for weeks or possibly even months.

SATURDAY, JUNE 27, 2009

Hindustan Times
NEW DELHI · METRO

Weather today: An unruly day. The afternoon will be hot. High 42°C, Low 27°C

SPORT: CONFEDERATIONS CUP
Alves scores, Brazil in final P3

WORLD: MATERIAL WOMAN
Madonna made $110 mn in 2008 P17

MICHAEL JACKSON · AUGUST 29, 1958 – JUNE 25, 2009

End of a thriller

Power protests turn violent, govt gropes in the dark
Back to pre-privatisation dark ages as discom staff abandon helplines

HT Correspondent
New Delhi, June 26

THE GOVERNMENT reacted to a report in Hindustan Times on the power crisis in the city, with meetings. And missed a potentially explosive situation unfolding on the power front: dysfunctional complaint centres.

CARDIAC ARREST?

500 Megawatt
The approximate power Delhi fell short by on Friday. One Megawatt can light up 20,000 lightbulbs.

World's greatest pop star was known from Noida to Nevada
Brook Barnes
Los Angeles

When MJ came to Mumbai
Vaibhav Purandare
Mumbai, June 26

30 Pages · Rs. 3.00
City Edition
Delhi
www.thehindu.com

SATURDAY, JUNE 27, 2009

THE HINDU
INDIA'S NATIONAL NEWSPAPER SINCE 1878

Printed at Chennai, Coimbatore, Bangalore, Hyderabad, Madurai, Delhi, Visakhapatnam, Thiruvananthapuram, Kochi, Vijayawada, Mangalore, Tiruchirapalli and Kolkata.

JUGALBANDI GOES GLOBAL
PAGE 2

INDIA IS MORE THAN AfPAK
PAGE 13

SUCCESSION PLAN OF BIRLA

SERENA IN LAST 16
HAI SPORTS PAGE

Michael Jackson is dead
The 50-year-old king of pop was on verge of another comeback

LOS ANGELES: For his legions of fans, he was the Peter Pan of pop music; the little boy who refused to grow up. But on the verge of another comeback, he is suddenly gone, this time for good.

GLOBAL SUPERSTAR: Michael Jackson responds to the crowd in front of the

Krishna, Qureshi meet in Trieste
"Vast potential" for India-Pakistan bilateral relationship

Special Correspondent

NEW DELHI: In line with the new bilateral direction Prime Minister Manmohan Singh set in meeting with President Asif Ali Zardari earlier this month, the Foreign Ministers of India and Pakistan met on the sidelines of a G8 Outreach meeting in Trieste, Italy, on Friday to take stock of the relationship.

HT CITY
New Delhi, Saturday June 27, 2009, 16 Pages

STOP PRESS

FARRAH ANGEL FAWCETT NO MORE
Farrah Fawcett, whose smile and feathered blond mane made her one of the reigning sex symbols of the 1970s, passed away on Thursday. She was 62. Fawcett, who first vaulted to stardom as an alluring member of herself in a red swimsuit, was diagnosed with anal cancer in late 2006.
—Reuters

AS THE WORLD COMES TO TERMS WITH THE SUDDEN AND SHOCKING DEATH OF POP ICON MICHAEL JACKSON, FANS PAY HOMAGE TO THE MAN EVERYONE LOVED TO HATE

END OF AN ERA

THE CONTROVERSIES

Jackson sold some 750 million records during his career.
Thriller (1982) was one of his

On July 13 2009, Jackson was slated to begin his comeback tour in London. Within the first

LATE CITY | NEW DELHI | SATURDAY | JUNE 27 | 2009 | 24 + 6 (NEWSLINE)

The Indian EXPRESS
JOURNALISM

www.indianexpress.com

MICHAEL, YOUR MUSIC WILL PLAY ON.
Nokia XpressMusic pays tribute to one of the greatest music legends of our times.

NOKIA
Connecting People

Quick TAKES

Law soon for judges to disclose their assets: Moily

ACCOUNTABILITY ■ 'Draft ready…will keep judiciary in the loop for reforms'

MANEESH CHHIBBER
NEW DELHI, JUNE 26

UNION Minister for Law and Justice M. Veerappa Moily today said the government would soon make it mandatory for the members of the higher judiciary, including the Chief Justice of India, Judges of the Supreme Court and the state High Courts, to disclose their assets and liabilities.

First Taliban strike in PoK: 2 killed in Muzaffarabad
ISLAMABAD: The Taliban carried out their first suicide attack in Pakistan-occupied Kashmir on Friday, killing two Pakistani soldiers and injuring three in the provincial capital of Muzaffarabad.

MICHAEL JACKSON 1958-2009

The King
moonwalks to heaven

Sensex rebounds, soars 419 points
MUMBAI: The Sensex surged over 419 points Friday to settle

Reservo running half of la year's lev

THE BIG D

BENNETT, COLEMAN & CO. LTD. · ESTABLISHED 1838 | NEW DELHI | SATURDAY JUNE 27, 2009 | PAGES 74 | CAPITAL PRICE Rs 3.00 · OR Rs. 4.50 WITH NAVBHARAT TIMES

THE TIMES OF INDIA

MICHAEL, YOUR MUSIC WILL PLAY ON.
Nokia XpressMusic pays tribute to one of the greatest music legends of our times.

NOKIA
Connecting People

ty reels under worst power crisis in years

■ Up To 12 Hrs, ffic Lights Go The Blink As kv Unit Fails

Highest-Ever Demand	4,117 MW (Friday, 3pm)
Shortfall	1,040 MW

Worst Power Cuts
Greater Kailash-I	5-6 hours
Krishna Nagar	10 hrs
Dwarka	10-12 hrs
Vasant Kunj	8 hrs

Loadshedding
In June '08	28.5
In June '09	

Output down 12% in hydel units

Peter Pan Of Pop Dies On Eve Of Comeback ● **Ended $500m In Debt** ● **Net Slows Down**

Jacko Moonwalks Into HIStory
Brooks Barnes

AUGUST 29, 1958–JUNE 25, 2009

For his legions of fans, he was the Peter Pan of pop: the little boy who refused to grow up.

If you enter this world knowing you are loved and you leave this world knowing the same, then everything that happens in between can be dealt with
— MICHAEL JACKSON

Mystery Of The Missing Doctor

WEEKEND EDITION

THE ASIAN AGE

CPM: Inability to project credible PM nominee led to loss …2
AZAD: Ban onscreen rape, murder before smoking … 3
ZARDARI, Army in power tussle over India plans … 8
VATICAN rivalry may hit John Paul II beatification … 10

Vol. 16 No. 131 NEW DELHI · SATURDAY · 27 JUNE 2009 http://www.asianage.com

windows

2 N-sites on Hillary India visit agenda
LALIT K. JHA

WASHINGTON
June 26: India is likely to announce locations for two nuclear power plants, which would be made available to American companies, during US secretary of state Hillary Clinton's visit to New Delhi next month, a top Obama administration official said.

Obama invites Singh to US
New Delhi: US national security adviser General James Jones called on PM Manmohan Singh and conveyed US President Barack Obama's invitation to visit the White House.

JACKSON BREAKS WORLD'S HEART

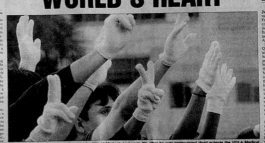

Fans held up single gloved hands in celebration of Michael Jackson's life after he was pronounced dead outside the UCLA Medical

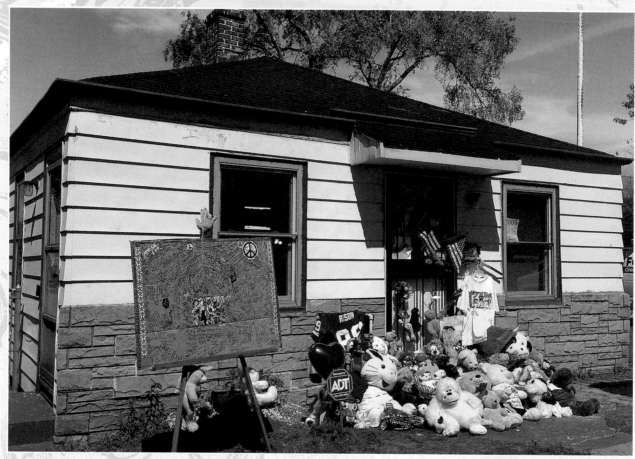

The news was particularly shocking even after details came to light about his physical condition. Though the tabloid press and celebrity bloggers had been speculative about a decline in the singer's health, early indications were that the singer was generally healthy for a 50-year old man—he had recently passed a rigorous five hour physical that the insurers of his London shows had insisted upon. He was in the process of getting fit for the grueling show circuit when he passed away, reportedly saying that he had to keep "the machine well-oiled" for the concerts.

London was supposed to be the springboard that brought Michael Jackson back. His drawing power was as big as ever—the 50 shows at O2 Arena had sold out quickly, and there was a renewed optimism that Jackson was more ready than ever to reclaim his throne as the King of Pop. With a renewed passion for entertaining, inimitable talent, and a track record unlike anyone else in the history of music, the sky was the limit.

But in the end, it seemed that the heart that had

(above) Fans left objects and created a memorial outside Jackson's boyhood home in Gary, Indiana. The city's favorite son moved away over four decades ago, but he remained a beloved part of Gary's culture.

(opposite) The famous marquee of the Apollo Theater is adorned with a message of memory for Michael Jackson. Venues around the country quickly followed suit after the news broke of Jackson's death.

cared so much for his children—and indeed children around the world—that was often so tragically misunderstood, simply gave out and no amount of resuscitation was going to bring it back.

Jackson had given so much of himself to others that it was wonderful to see the outpouring of love from family and fans that began as soon as the news broke and continues to this day. The King of Pop may be gone, but his legacy will live on forever. The light that burned twice as bright, burned half as long. ★

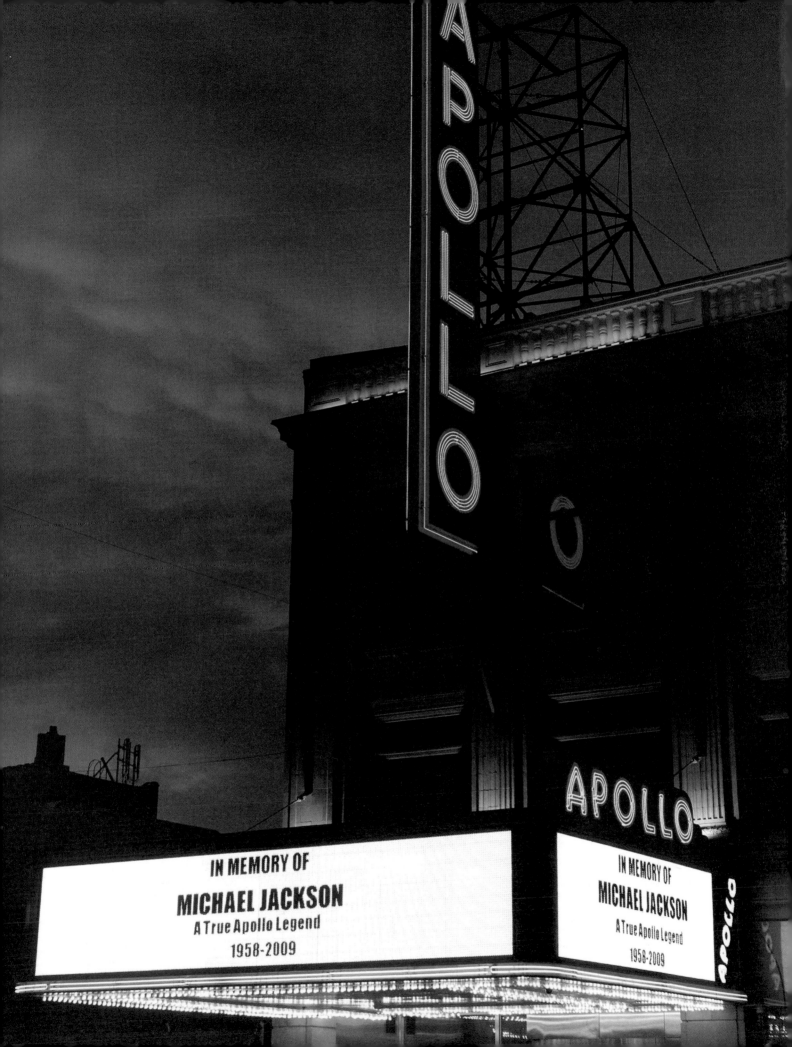

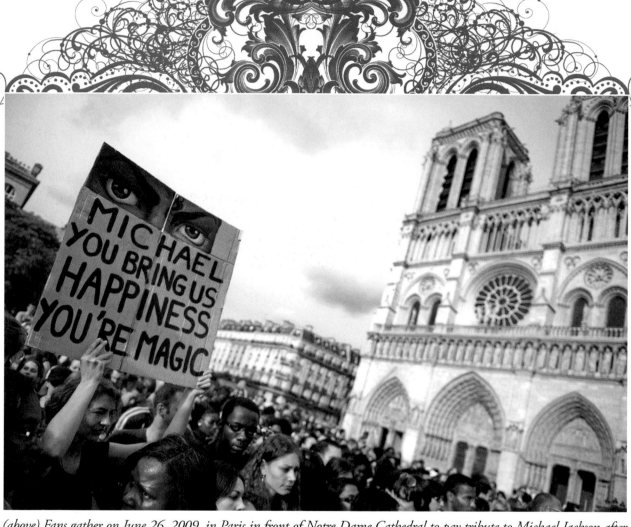

(above) Fans gather on June 26, 2009, in Paris in front of Notre Dame Cathedral to pay tribute to Michael Jackson after his unexpected death in Los Angeles. Jackson died on June 25, 2009, after suffering a cardiac arrest, sending shockwaves sweeping around the globe and tributes pouring in for the tortured music icon revered worldwide as the "King of Pop."

(opposite) A mourner in Japan places a wreath at a Jackson memorial. The shrine is in the lobby of a theater screening Thriller *in honor of Jackson's life.*

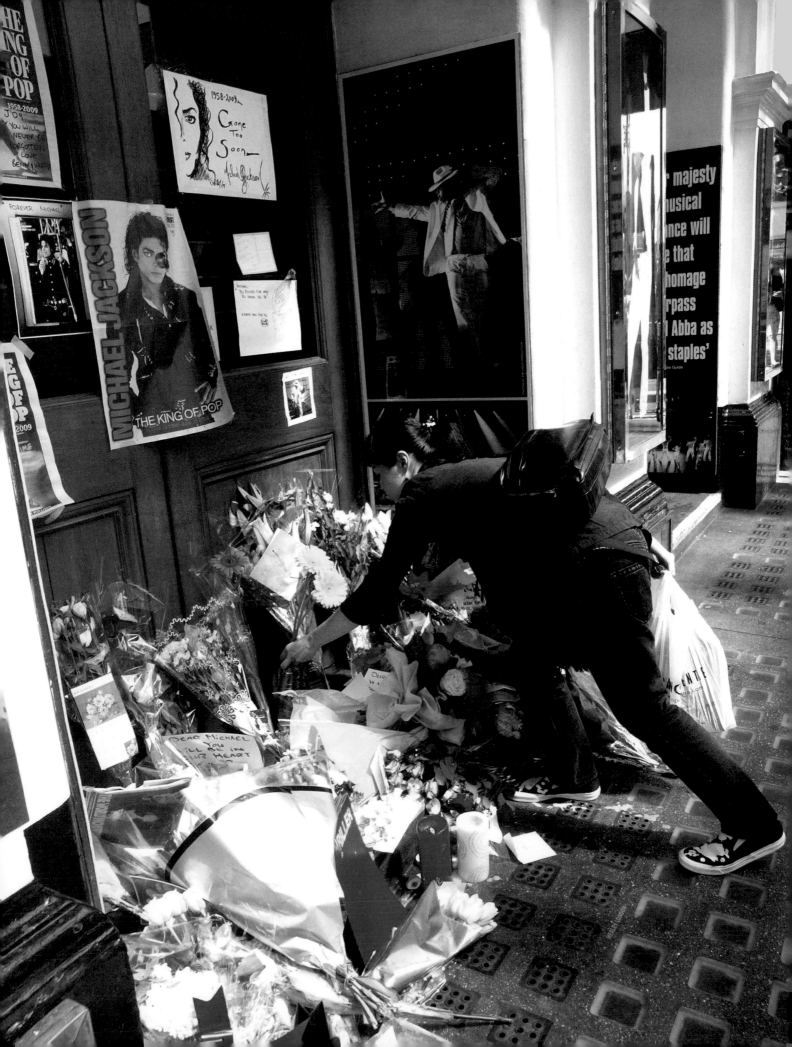

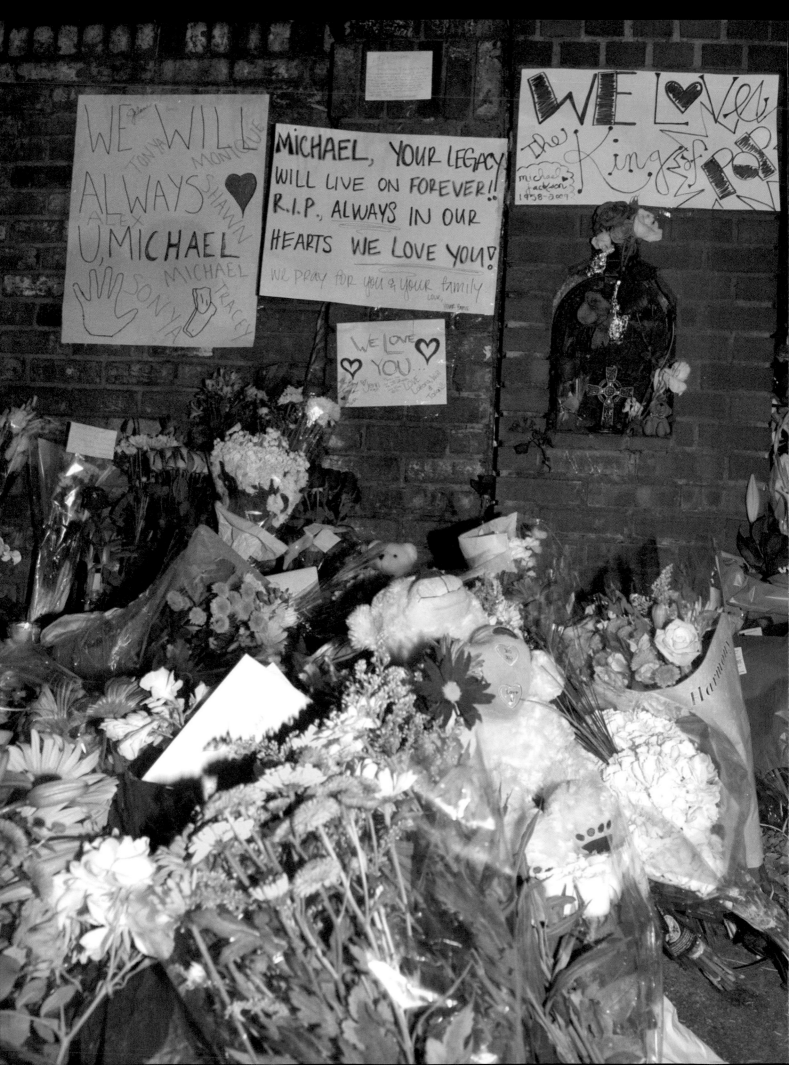

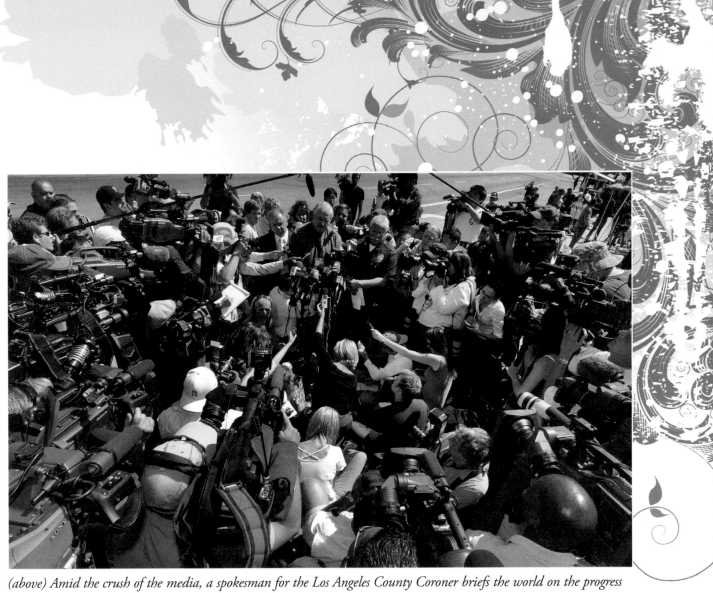

(above) Amid the crush of the media, a spokesman for the Los Angeles County Coroner briefs the world on the progress of Michael Jackson's autopsy. There were few details to report: the spokesman said that results from tests may not be known for six to eight weeks.

(opposite) The Jackson home in Encino, California, quickly turned into a memorial as the Jackson family mourned. Just days later, Joe and Janet were able to compose themselves enough to appear at the BET Music Awards, though only Janet appeared on stage. She thanked the fans for their support.

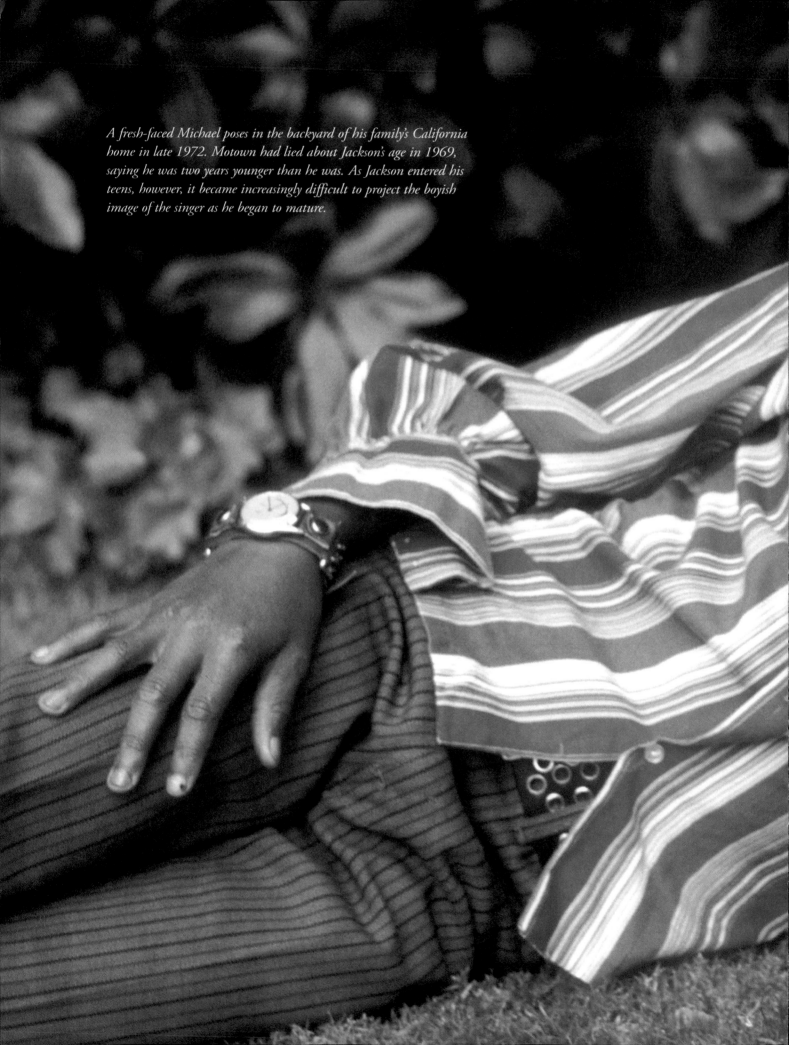

A fresh-faced Michael poses in the backyard of his family's California home in late 1972. Motown had lied about Jackson's age in 1969, saying he was two years younger than he was. As Jackson entered his teens, however, it became increasingly difficult to project the boyish image of the singer as he began to mature.

The Jackson 5
and the Early Years

Born into a blue-collar but prodigious musical family in Gary, Indiana, Michael Joseph Jackson seemed to have the cards stacked against him from birth. One of nine African American children from a working-class steel-mill town, there was little to predict that he would someday reign as the King of Pop.

Jackson had a gift for showmanship at an early age, and his energy and desire to perform was boundless. When he wowed attendees at a Christmas pageant at age five, father Joe Jackson knew it was time to add Michael to his fledgling family band, The Jacksons.

Originally starting in the background of the band, playing percussion and singing backup vocals while brother Jermaine fronted the group made up of his older brothers, Michael's exceptional gifts soon became apparent—a statement in itself for a family that would sell more records than any other in music history.

Pictured just before their big break in Motown, The Jackson 5 pose in Chicago in 1968. Michael is at the front while Tito, Marlon, and Jermaine stand left to right in the middle. Jackie stands tall at the rear.

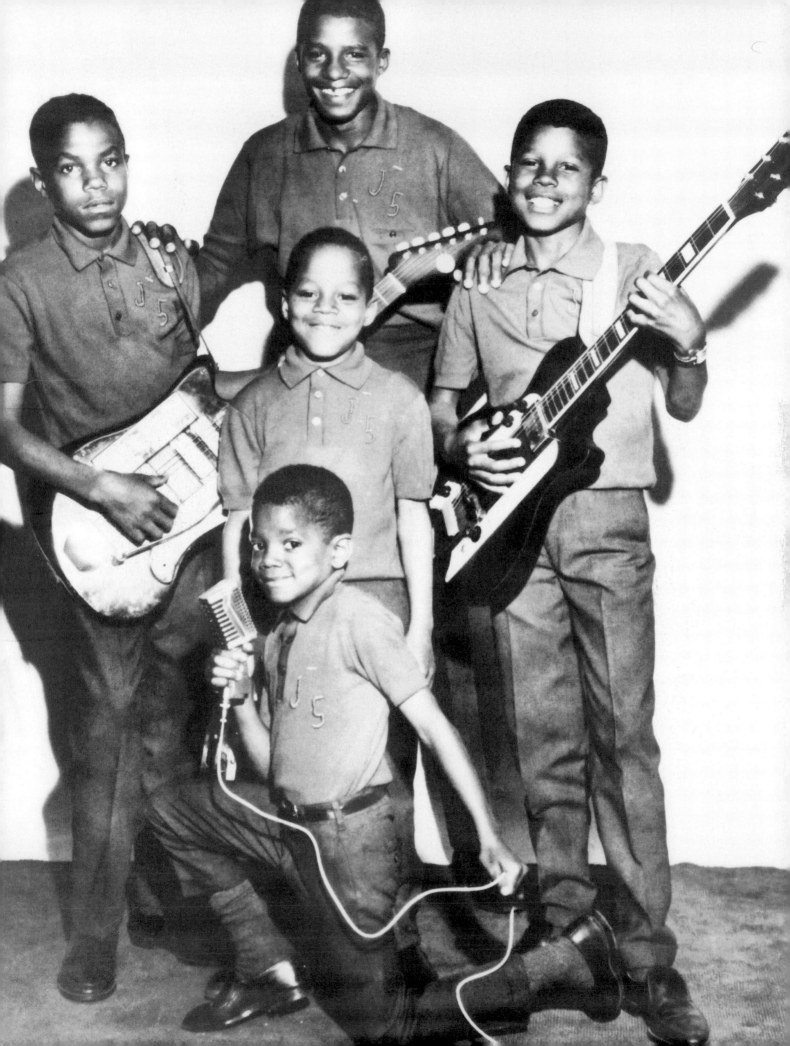

The star of the show: Michael's voice was universally praised among reviewers, cited for its fantastic depth and hard-spun emotion in a brash falsetto. Dubbed "bubblegum soul," the music of The Jackson 5 was as big as that of any other artist in the early 1970s.

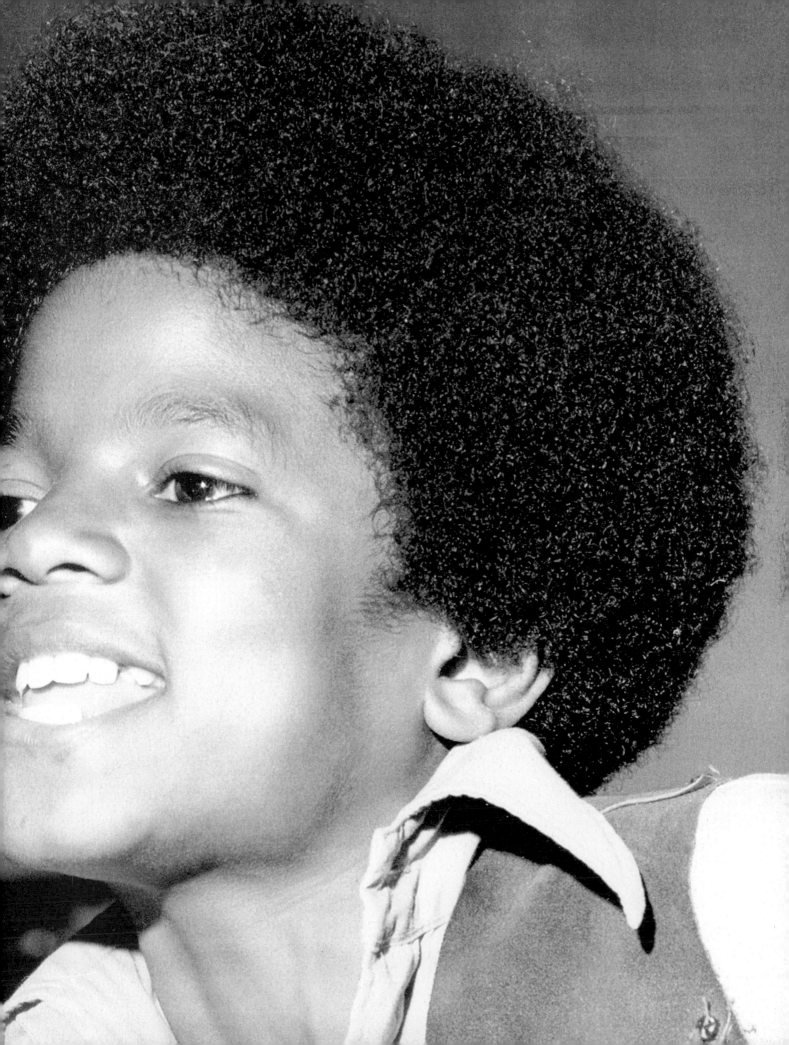

Taskmaster Joe re-christened the group The Jackson 5 and booked them in the talent show and nightclub circuit in the Midwest, where they often played seedy venues and glamour-less gigs. But pushed incessantly by the heavy hand of their father, their hard work paid off when they were signed to local label Steeltown in 1967.

The group quickly caught the eyes of Motown executives, and the big Detroit label soon bought the group's Steeltown contract and allied the family group with hit maker Diana Ross. By now it was clear that Michael, who was already sharing lead vocals with Jermaine, was going to be the face that would carry the group to fame and fortune.

Jackson's dancing, looks, and singing began taking their signature shape, and when Motown released their debut album, *Diana Ross Presents The Jackson 5*, it quickly became a hit. Motown was delighted at just how well the record sold: it peaked amazingly at number one on the charts, fueled by the infectious beats and Michael's distinctive singing. He sounded young, but the adult themes of the music resonated with fans and elevated four singles from the album to number one on Billboard's Hot 100.

The Jackson 5 were one of the biggest groups of the early 1970s and fans flocked to see and hear the fresh-faced and precocious lead singer. Motown quickly launched Michael's solo career and released four solo

Ed Sullivan, who had helped to break Elvis Presley and The Beatles into the big time in America, shakes hands with The Jackson 5 in December 1969. After the appearance, "Jacksonmania" began to sweep the nation as the family group became one of the biggest hit makers in music.

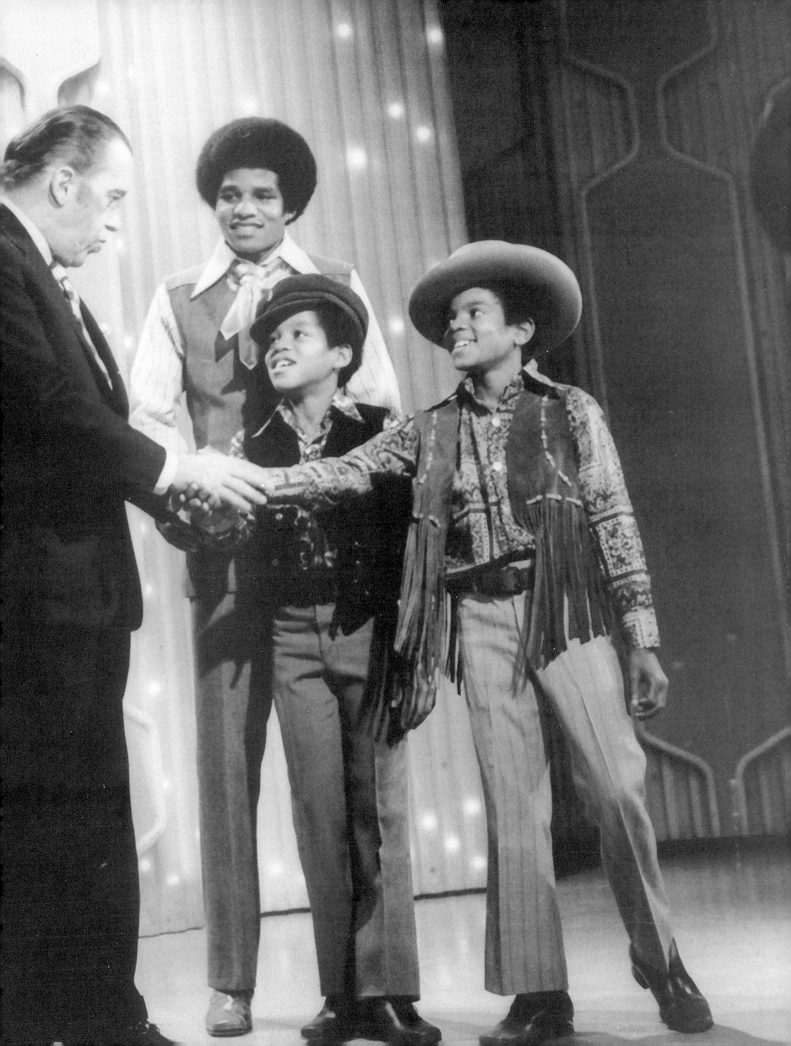

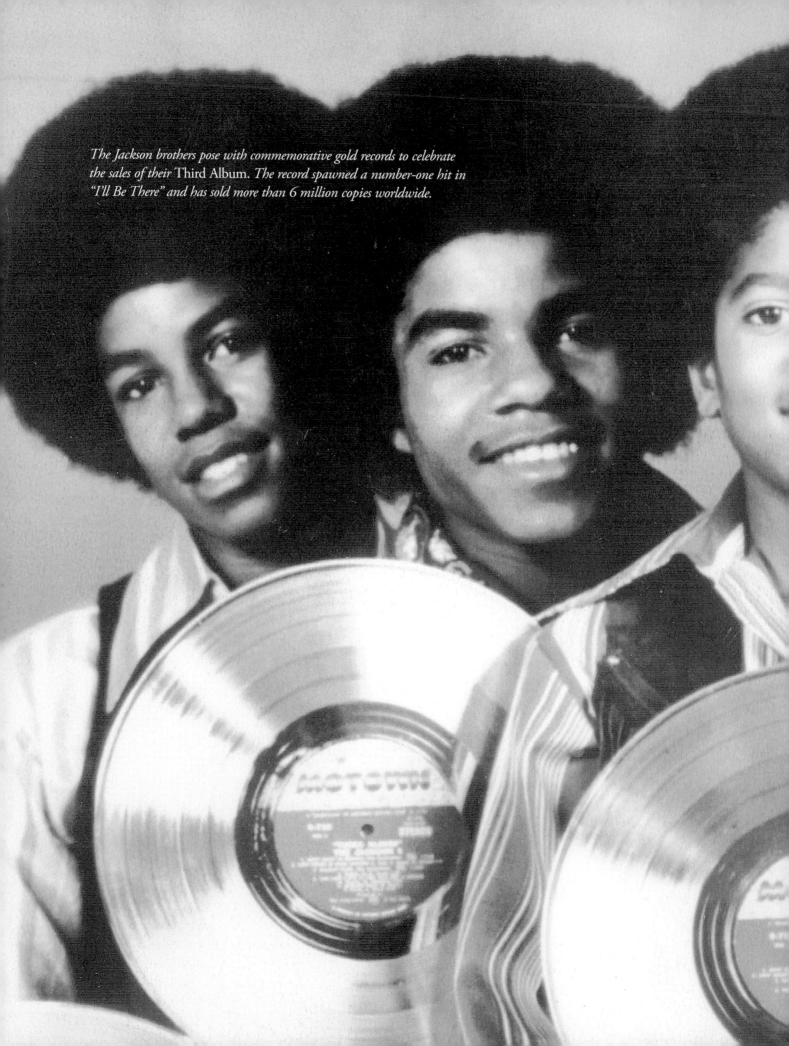

The Jackson brothers pose with commemorative gold records to celebrate the sales of their Third Album. *The record spawned a number-one hit in "I'll Be There" and has sold more than 6 million copies worldwide.*

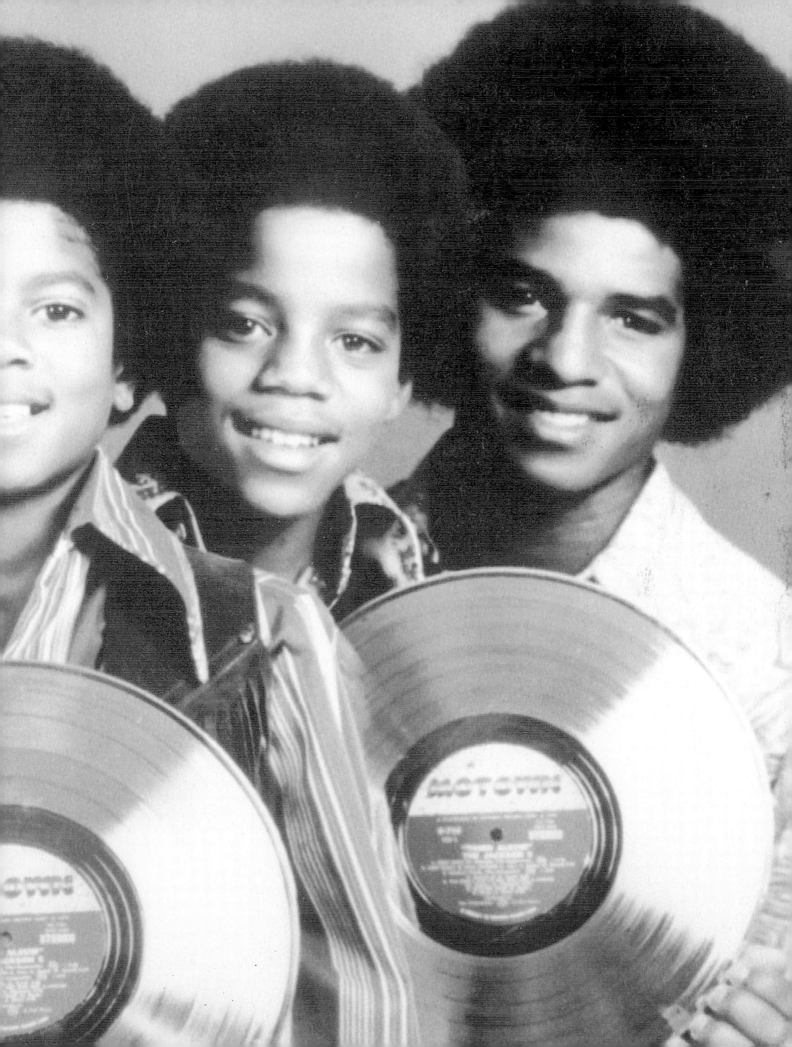

albums under The Jackson 5 banner. His first single, "Got to Be There," reached number four on the Billboard charts, and "Ben," the theme of the movie of the same name, went all the way to number one.

Sales of The Jackson 5 began to decline in the mid-1970s as musical tastes changed and the brothers got older and explored solo careers. None were able to come close to the success of Michael, but The Jackson 5 remained together until 1984, maintaining the family group even though the siblings were all pursuing other interests.

For Michael, performing with his brothers remained fun—he would stay on tour with them through *Thriller*. In fact, the world tour in support of *Thriller* was actually a Jackson 5 tour featuring all the brothers, though Michael was, by then, the unquestioned centerpiece.

The Jackson 5 had been enormously successful, but Michael was ready to break out of the carefully constructed shell that was created for him from a young age. As his solo career picked up momentum and the pudgy-faced boy that fans fell in love with grew up, Jackson matured into a man and artist with extraordinary talent on the brink of superstardom.★

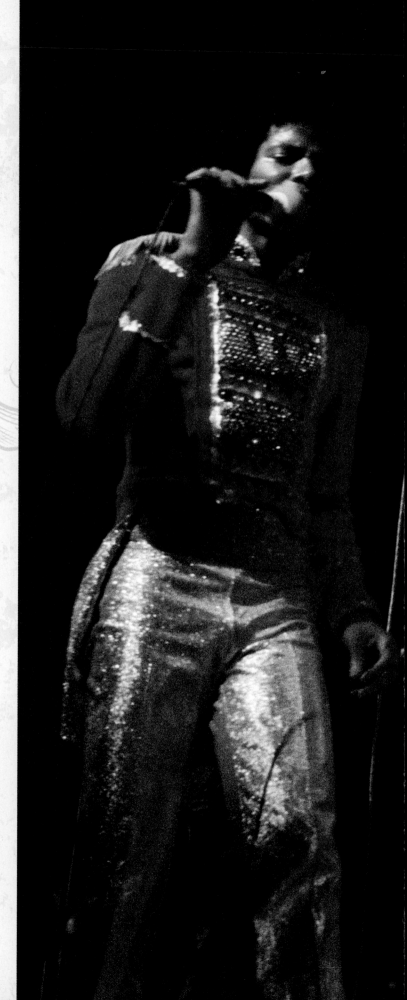

Newly re-christened, The Jacksons perform in London in 1977. No longer a boy, Michael (left) had truly become a man at the front of the band. The music was the same, but The Jacksons' image of fresh-faced young boys was gone for good. The group managed to last well into the 1980s, even after Thriller *captured the world's imagination.*

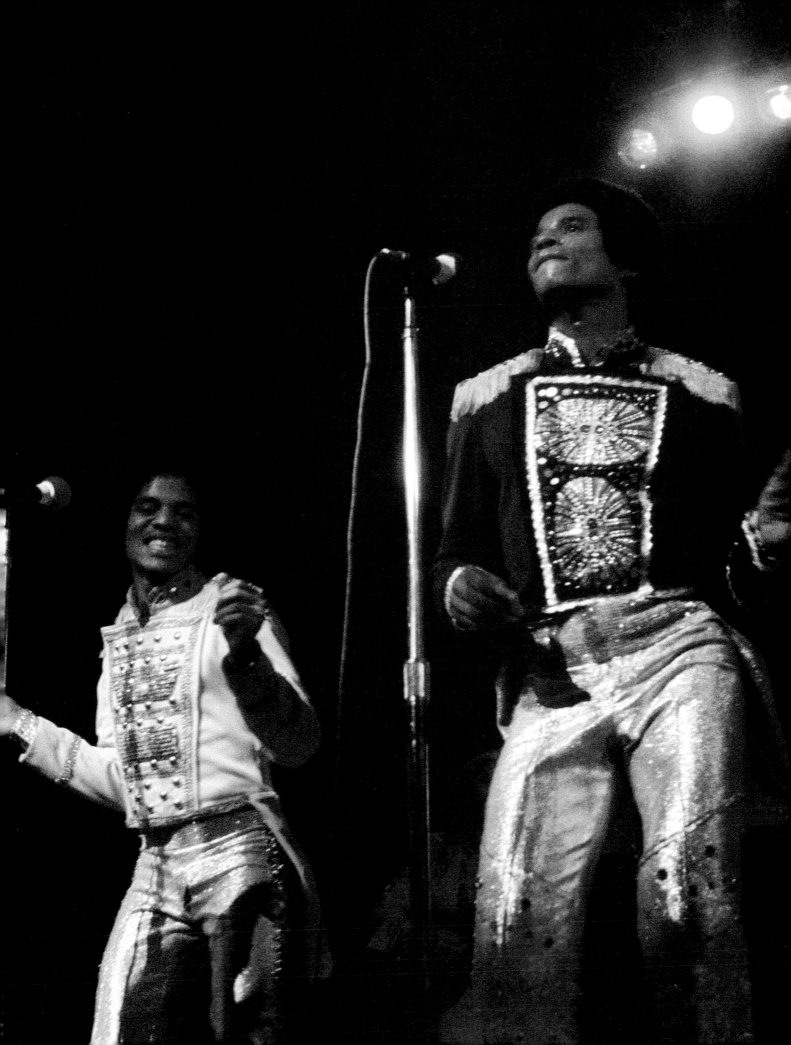

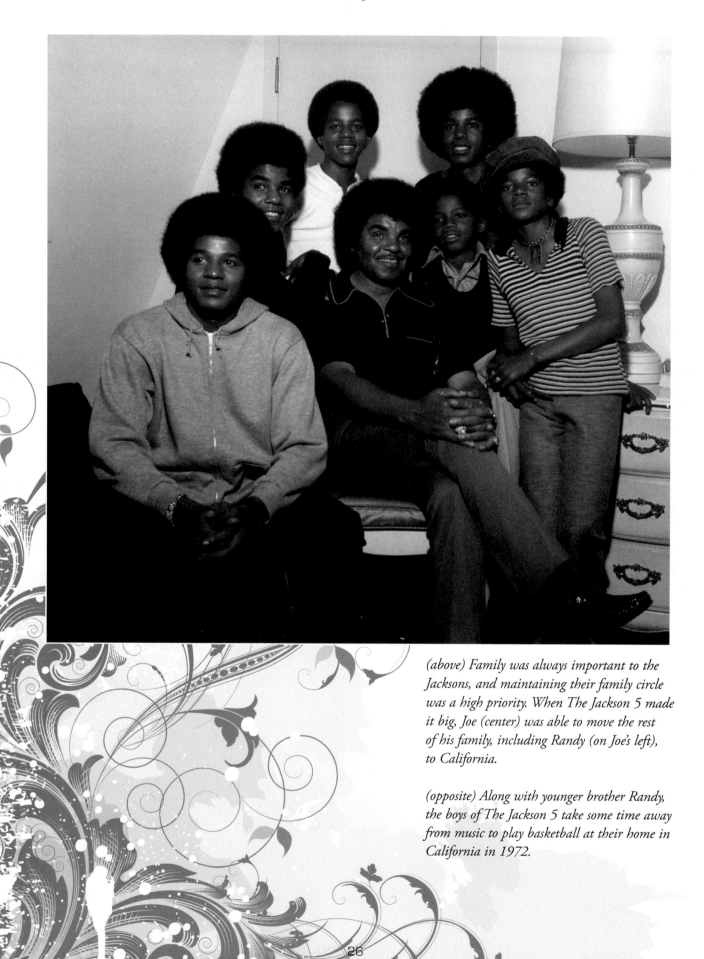

(above) Family was always important to the Jacksons, and maintaining their family circle was a high priority. When The Jackson 5 made it big, Joe (center) was able to move the rest of his family, including Randy (on Joe's left), to California.

(opposite) Along with younger brother Randy, the boys of The Jackson 5 take some time away from music to play basketball at their home in California in 1972.

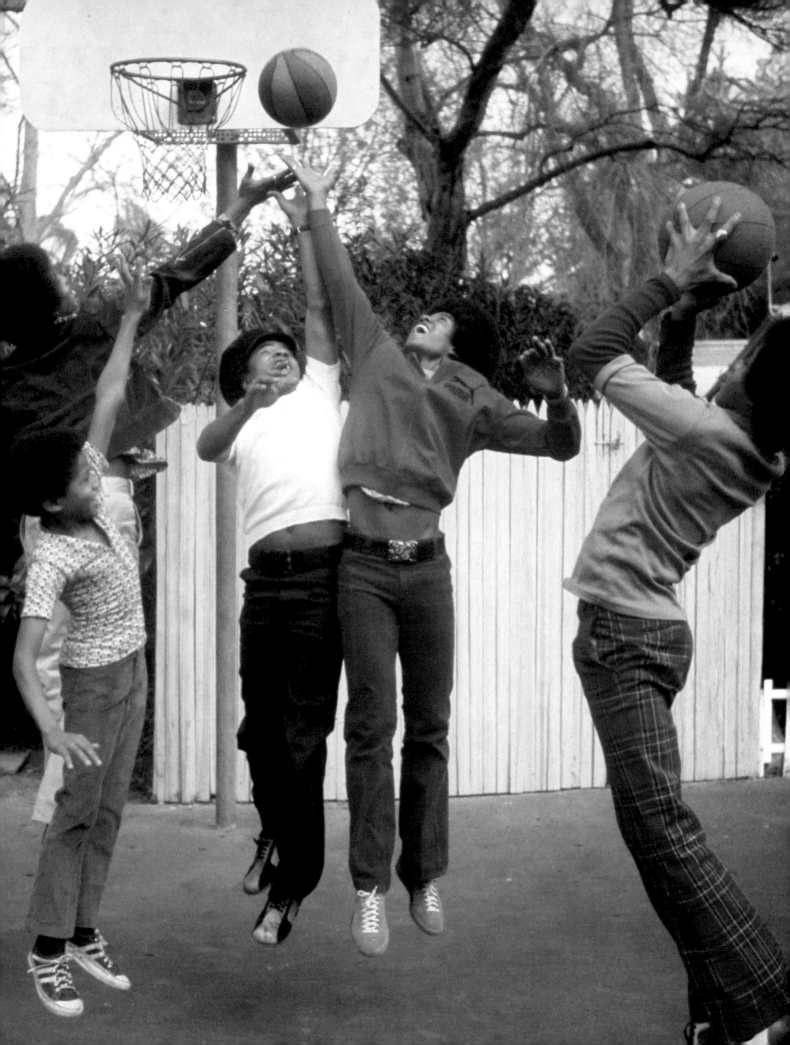

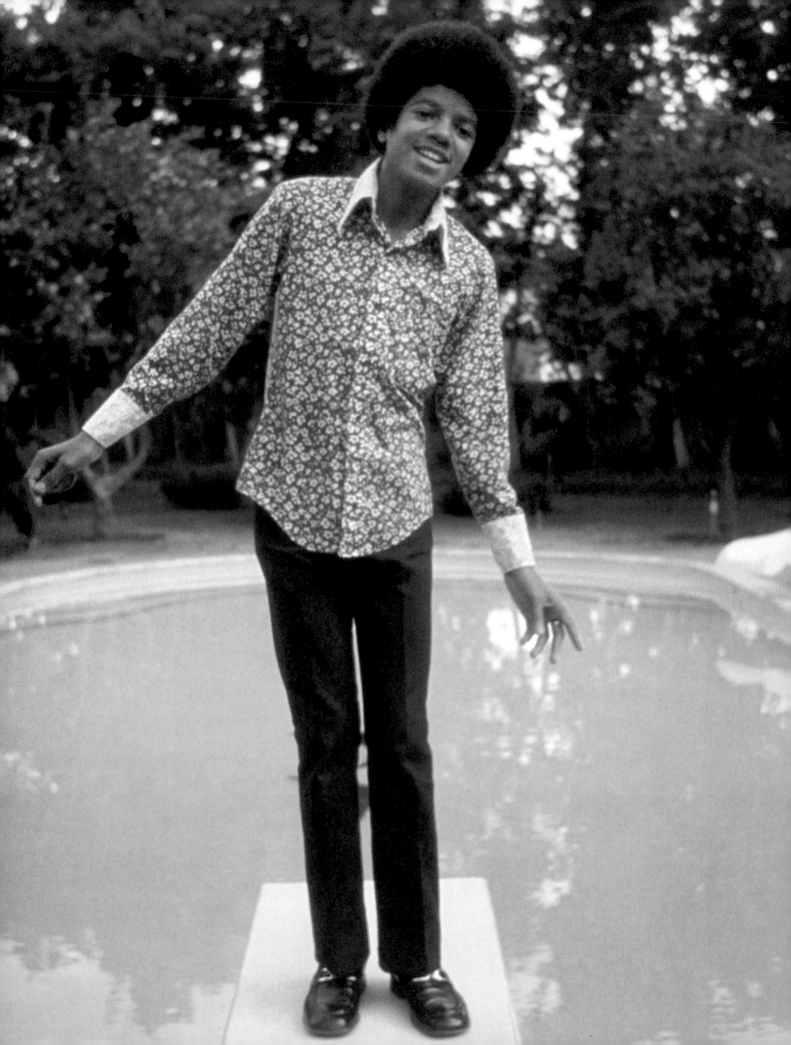

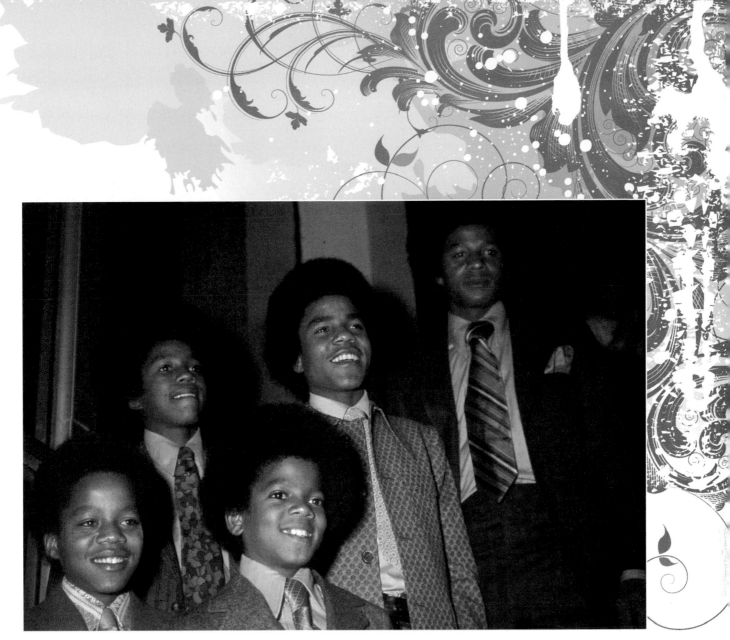

(above) The Jackson 5 stop for a picture at the 1970 NAACP Image Awards. By this time, the band had replaced the Temptations as Motown's top marketing focus, and Jackson memorabilia for kids was a fast-growing empire for the label. With the Jacksons' good looks, catchy songs, and proud soul, it's no wonder that the Image Awards recognized them.

(opposite) Michael poses on the diving board of the pool at the Jacksons' California home in late 1972. His solo career was already accelerating under the Motown and Jackson 5 banners, and he had notched several hit singles. That year's "Ben," however, was his first number one as a solo artist. His brothers began to venture out into solo work, with Jermaine also finding success.

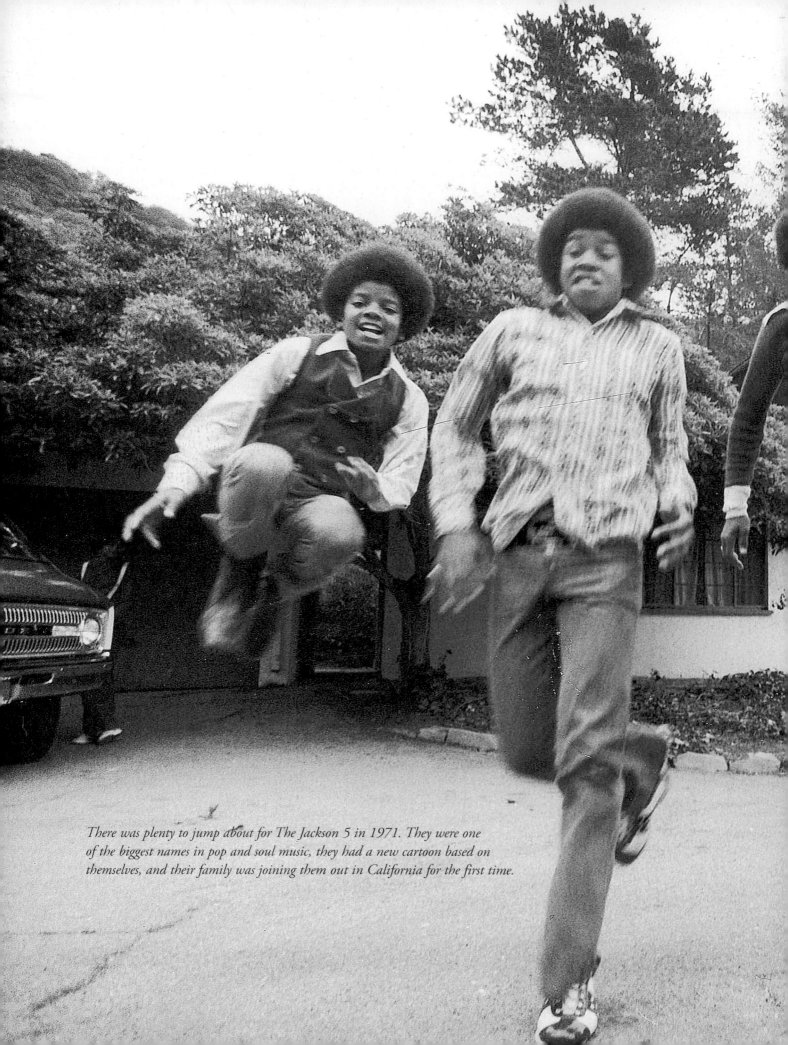

There was plenty to jump about for The Jackson 5 in 1971. They were one of the biggest names in pop and soul music, they had a new cartoon based on themselves, and their family was joining them out in California for the first time.

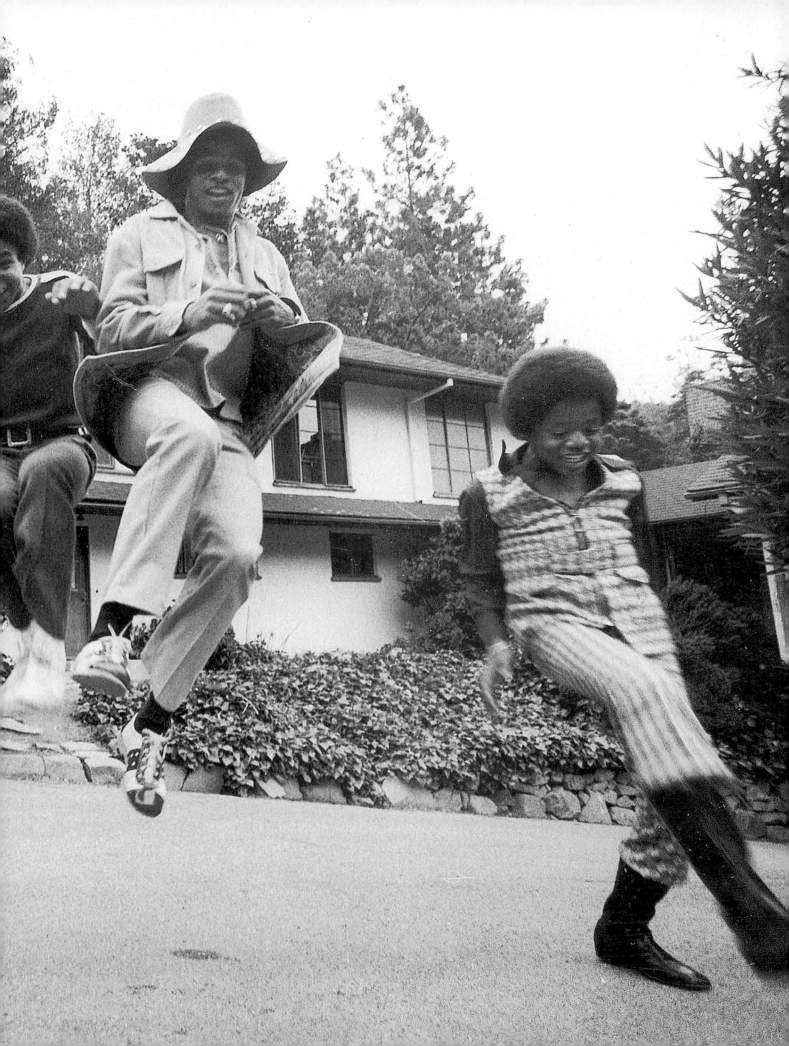

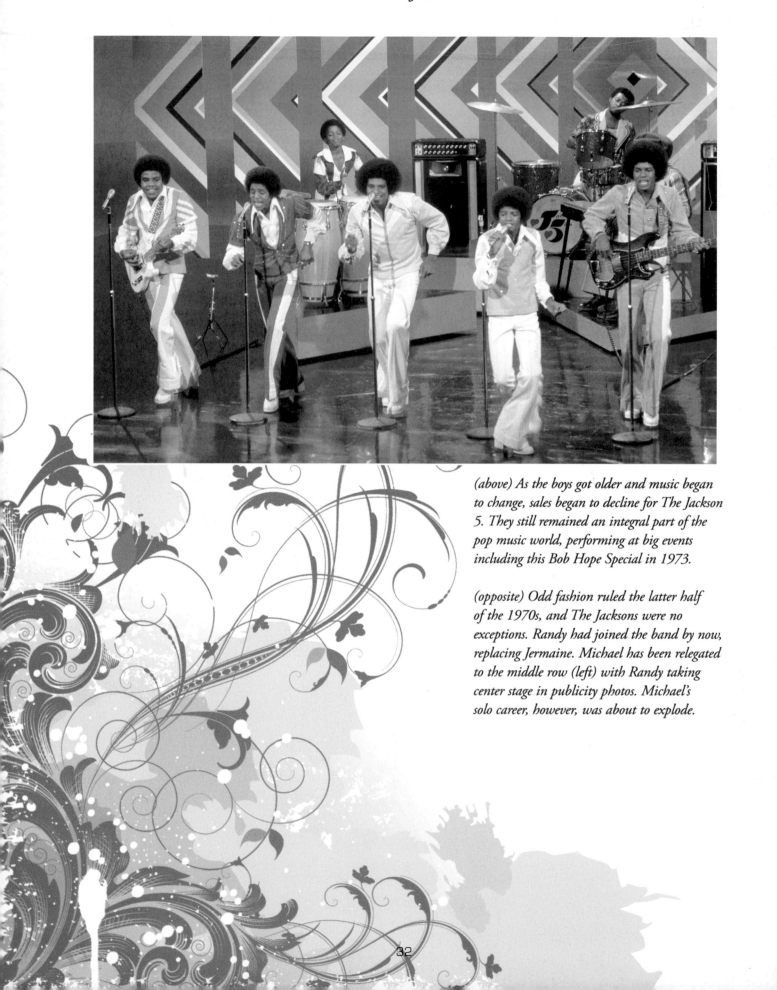

(above) As the boys got older and music began to change, sales began to decline for The Jackson 5. They still remained an integral part of the pop music world, performing at big events including this Bob Hope Special in 1973.

(opposite) Odd fashion ruled the latter half of the 1970s, and The Jacksons were no exceptions. Randy had joined the band by now, replacing Jermaine. Michael has been relegated to the middle row (left) with Randy taking center stage in publicity photos. Michael's solo career, however, was about to explode.

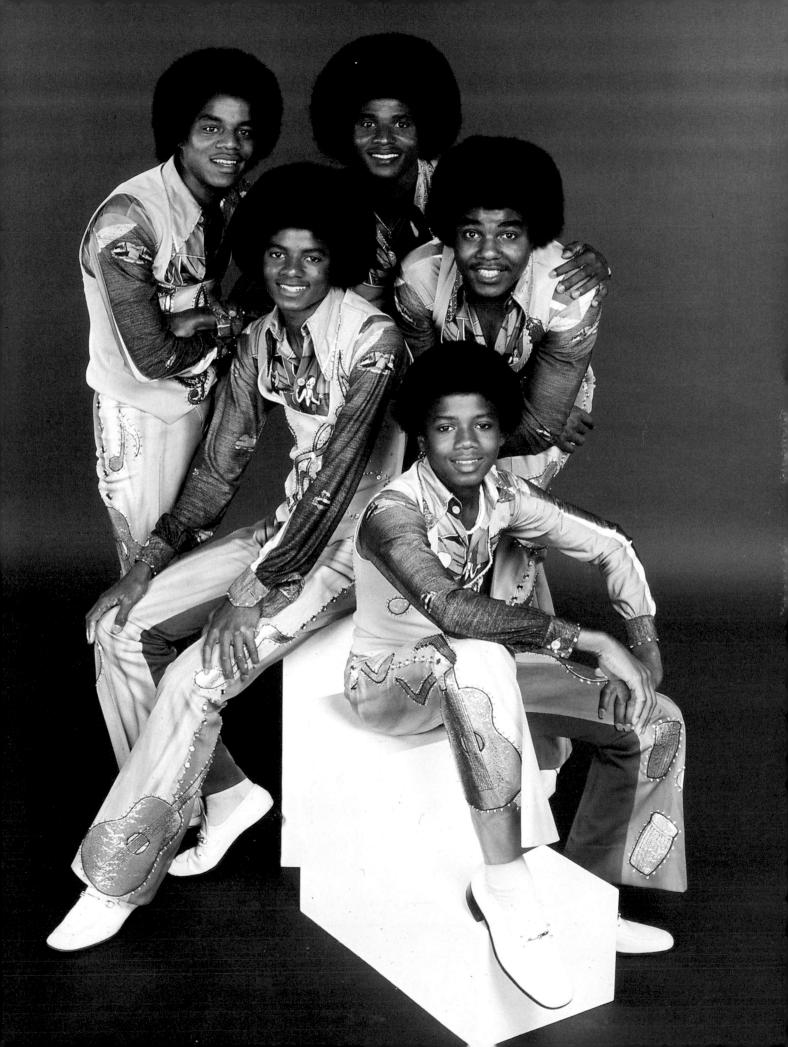

Super STARDOM

By 1979, Michael was a veteran of the recording process. Off the Wall *was his fifth solo album, and it represented his breaking away from The Jacksons. The brothers, however, still continued to perform, tour, and record together for another five years.* Off the Wall *blew up beyond anything the family band had ever done, giving Michael two number-one hits.*

After meeting Michael Jackson on the set of the movie *The Wiz*, where Jackson was a sensation playing the Scarecrow, Quincy Jones decided to take Jackson under his wing and they proceeded to work together on Jackson's fifth studio album.

The resulting album, 1979's *Off the Wall*, proved to be a major hit. It sold more than 20 million copies to date and spawned four Top Ten singles—the first record to do so. Critically, the record earned Jackson his first Grammy since the early 1970s and myriad other music awards for what many still consider his finest album.

Jackson enjoyed his taste of success but wanted more. He wanted to be a big star and set out to make his next collaboration with Jones his personal ticket to fame and fortune, but even he could not have imagined how big *Thriller* would turn out to be.

By just about any measure, *Thriller* became the biggest album of all time, a true masterpiece in recording history. The album spent 37 weeks at number one and spent 80 weeks total on the charts. At its peak, *Thriller* was selling 1 million copies worldwide every week.

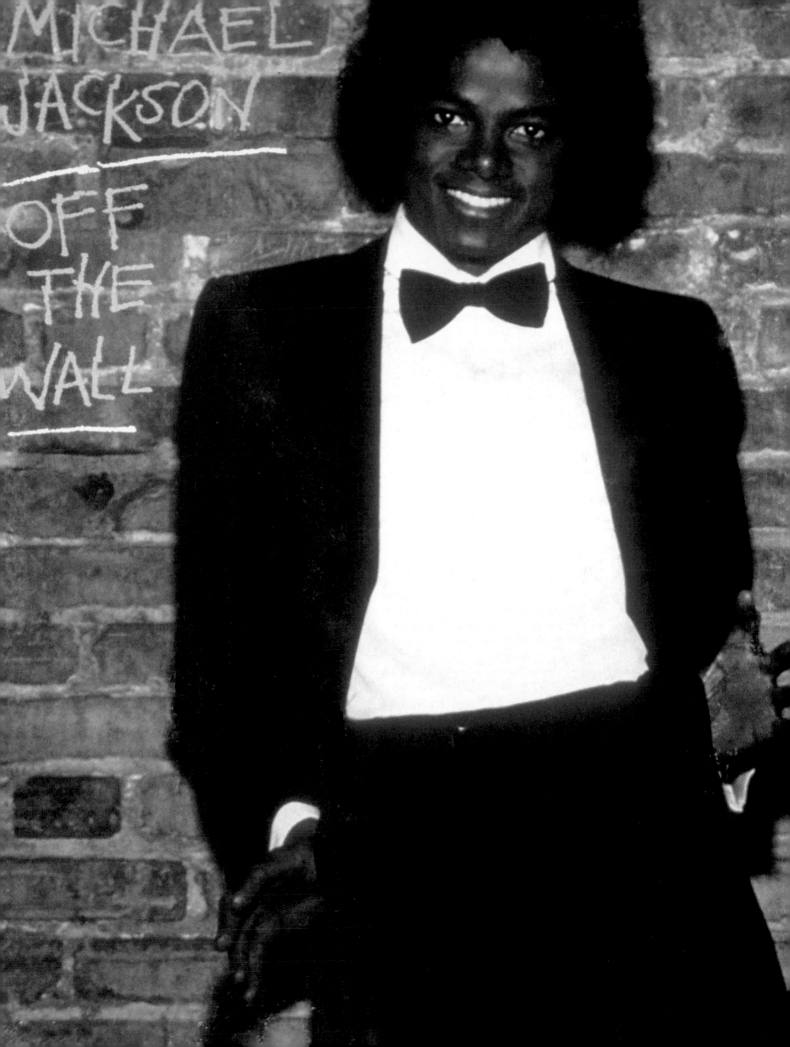

Cities big and small got to experience Thriller *live on the*
Victory *World Tour. Here, Michael is bringing the thunder*
in Buffalo, New York, in the summer of 1984.

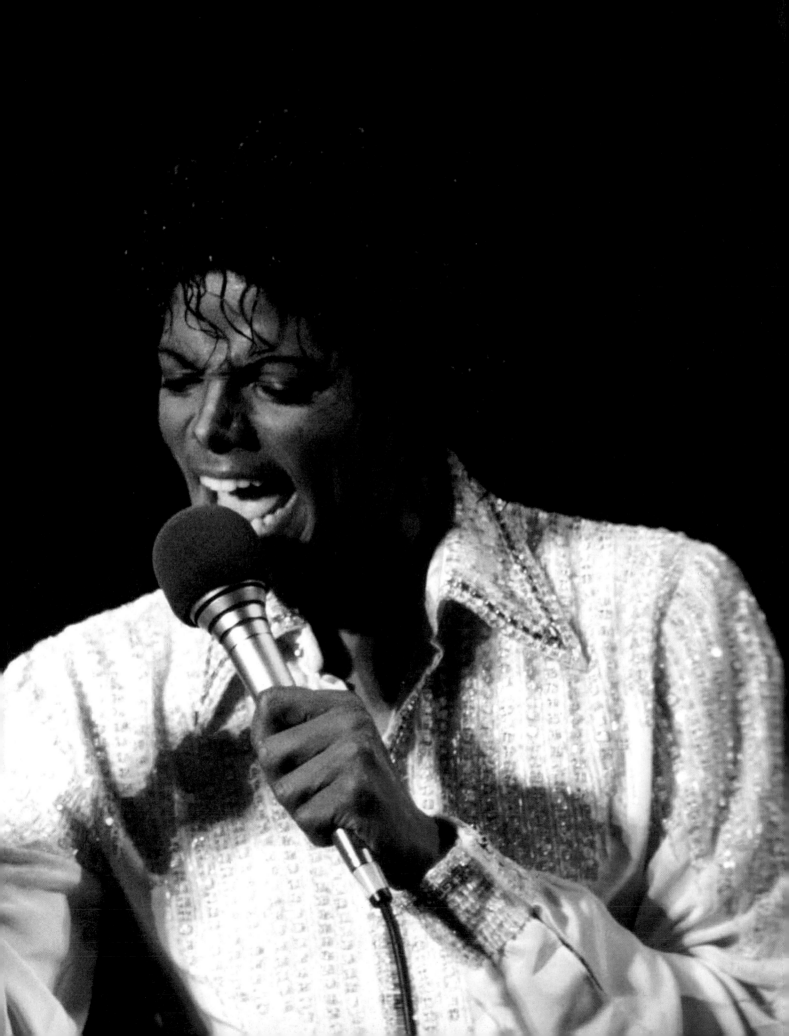

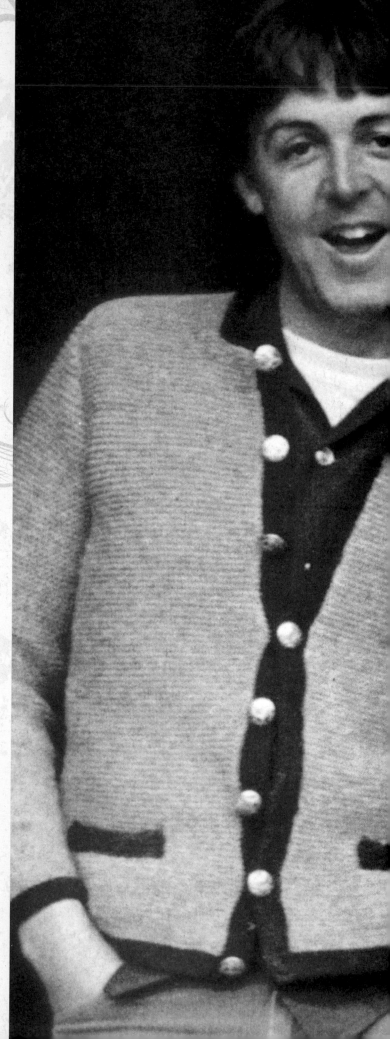

> *"I feel privileged to have hung out and worked with Michael. He was a massively talented boy man with a gentle soul. His music will be remembered forever and my memories of our time together will be happy ones."*
> — **Paul McCartney**

On a critical level, the record was nearly universally praised for its combination of styles that made it a pop legend. *Thriller* dominated the Grammys and won a total of eight awards in three genres.

With the boom of a new cable television channel called MTV, Jackson and his label seized upon the opportunity to make a visual splash through music videos. Realizing they could be great promotional tools and image-makers, the videos they created for "Billie Jean," "Beat It," and the title track became signature events in 1980s pop culture.

Thriller was more than just a record: it was a must-have item worldwide. Everyone seemed to own a copy: though the numbers are a bit murky, *Thriller* is estimated to have sold as many as 109 million copies around the world. There has never been anything like it since. With Jackson moon-walking, wearing his jacket and single glove, and hitting notes most singers could only dream of, he became an icon for a generation across multiple demographics. His popularity and talent was even compared to Elvis Presley and The Beatles, placing him among rock-and-roll royalty.

Paul McCartney poses with Michael in 1982. The former Beatle had become a friend and mentor to Jackson, with Michael even recording some of McCartney's material as early as Off the Wall. *The two became close, but had a falling out when Michael purchased the back catalog of Beatles songs in the 1990s.*

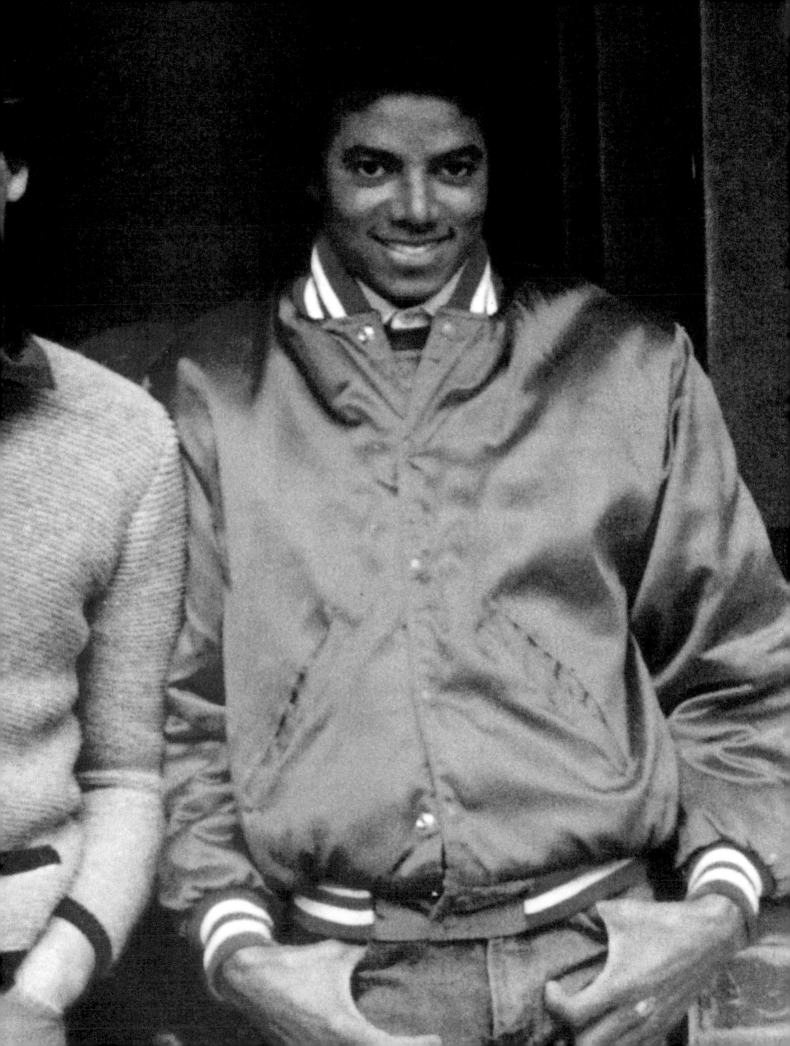

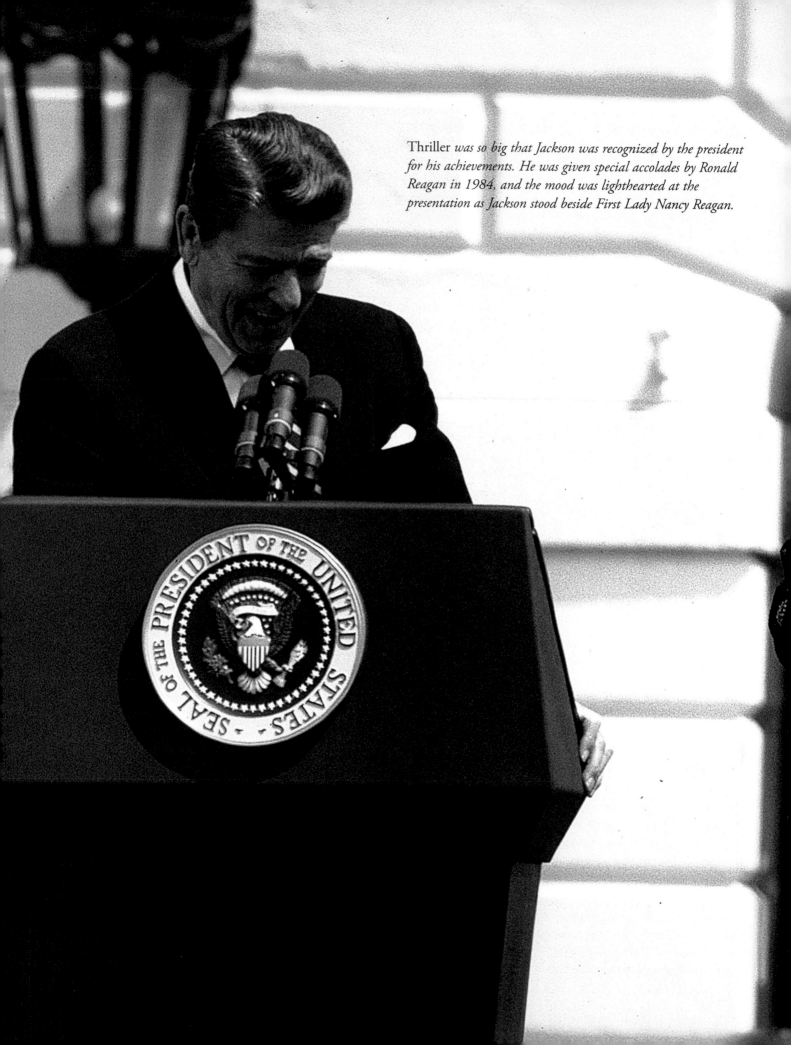

Thriller *was so big that Jackson was recognized by the president for his achievements. He was given special accolades by Ronald Reagan in 1984, and the mood was lighthearted at the presentation as Jackson stood beside First Lady Nancy Reagan.*

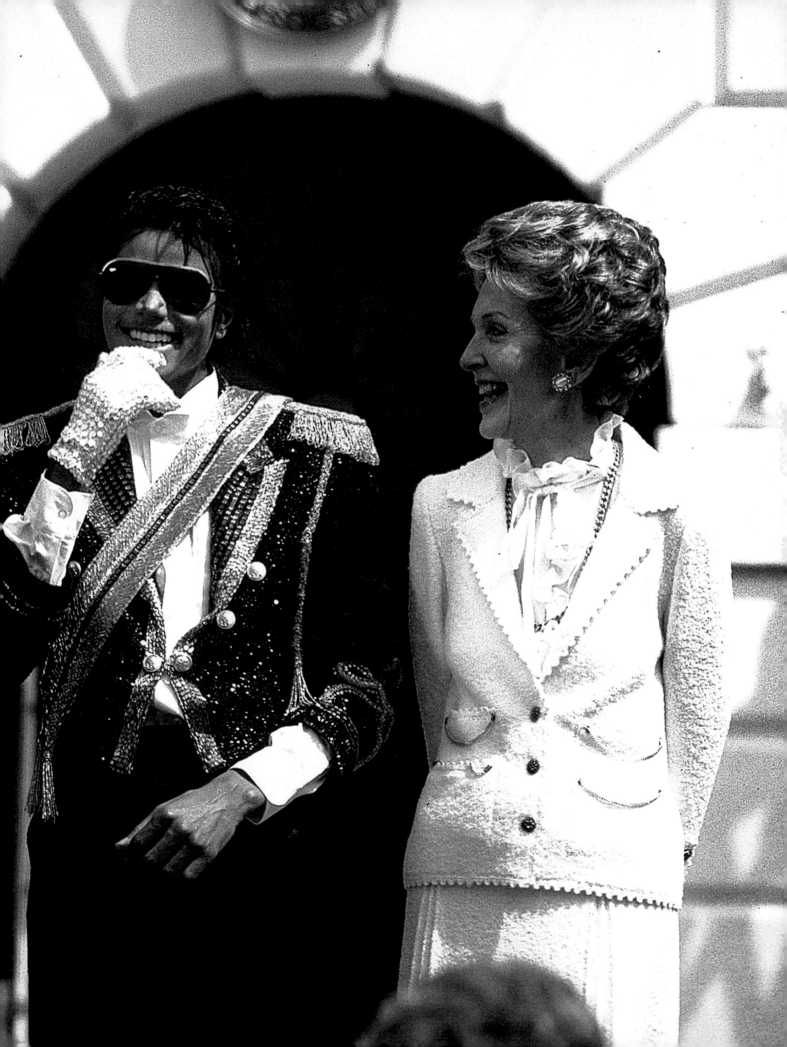

Five years after the release of *Thriller*, Jackson was prepared to issue his next album, *Bad*. Not content to rest on his laurels or let hype carry *Bad*, Jackson crafted the album meticulously and predicted that it would be even bigger than *Thriller*.

While nothing could match the success of *Thriller*, *Bad* was still wildly successful by any other measure. In fact, *Bad* did something *Thriller* could not: it spawned five number-one singles on the Billboard charts—another record that has never been broken. The album sold more than 30 million copies and cemented Jackson's status as the King of Pop.

The *Bad* World Tour was just as big as the album; playing in front of 4 million fans in 15 countries and featuring a spectacular stage and light show, the 16-month tour set the standard by which other major pop tours would later be judged. Jackson showed his support for charitable causes as well by reserving 400 tickets to each show for underprivileged children.

As the 1980s drew to a close, there was no doubt as to which entertainer had ruled the decade. With record sales exceeding 100 million, two huge world tours, and epic videos in heavy rotation on MTV, Michael Jackson reigned supreme in popular culture. ★

Michael and the rest of The Jacksons perform on the Victory World Tour. It seemed purely out of family loyalty that Michael agreed to do one last album and tour with his brothers; the record itself struggled with its identity, as each brother tried to lay his stamp on their songs.

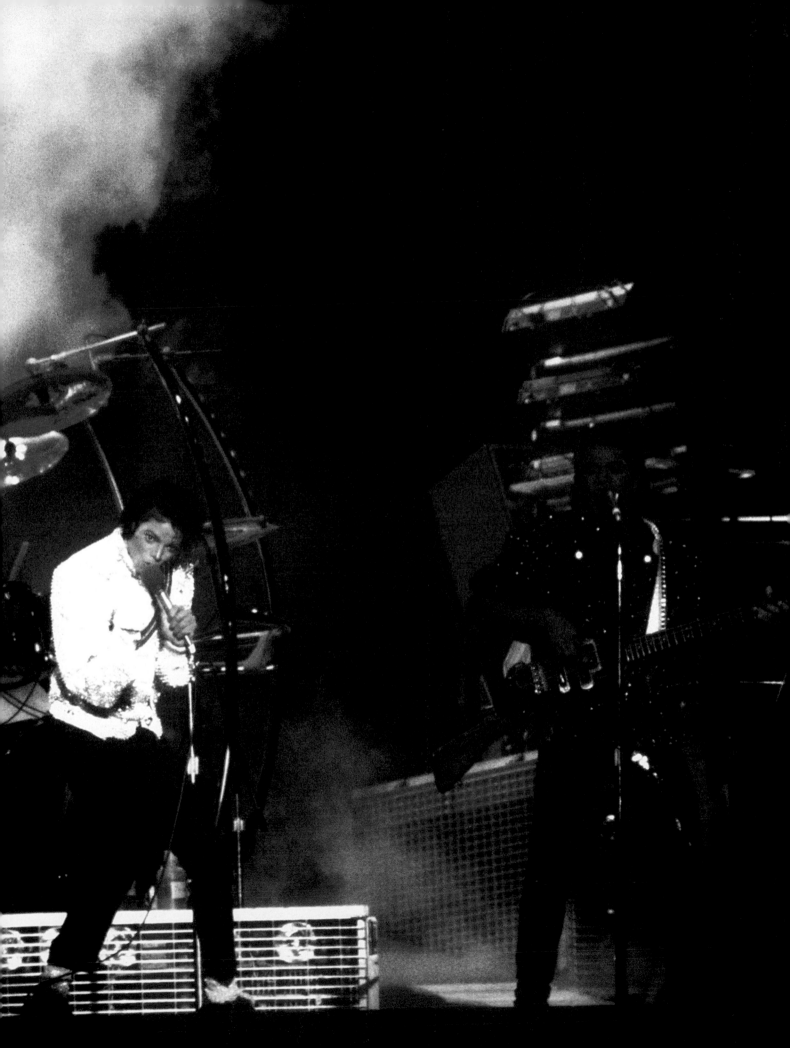

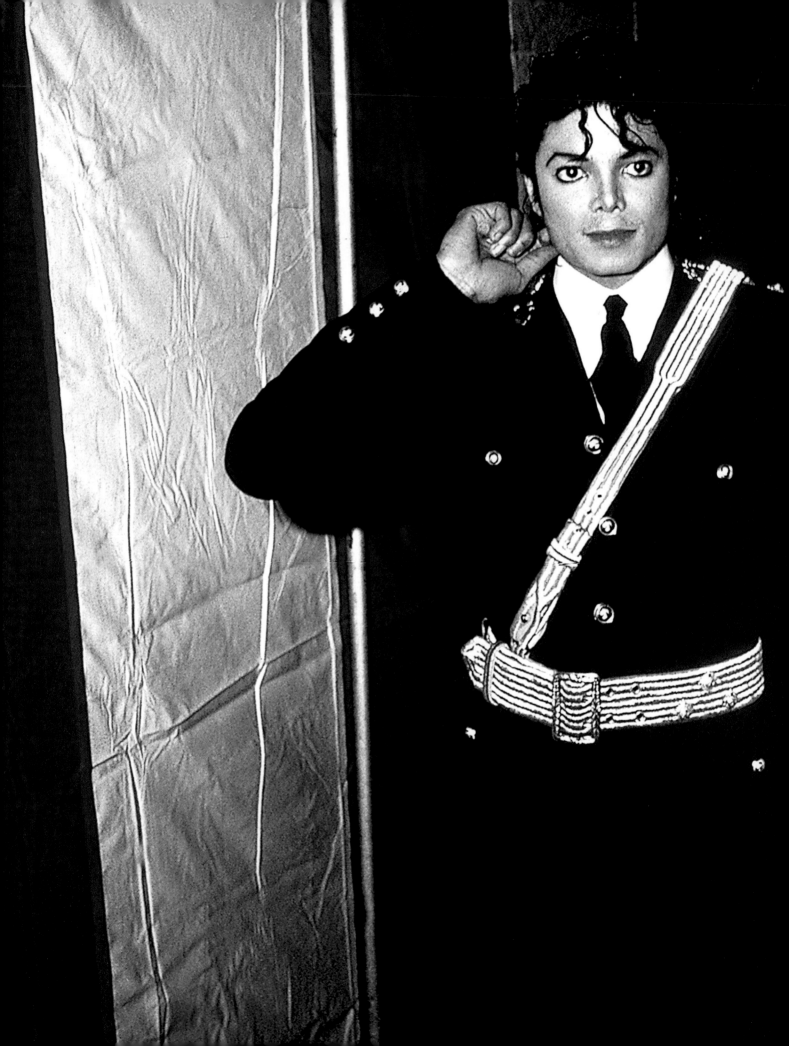

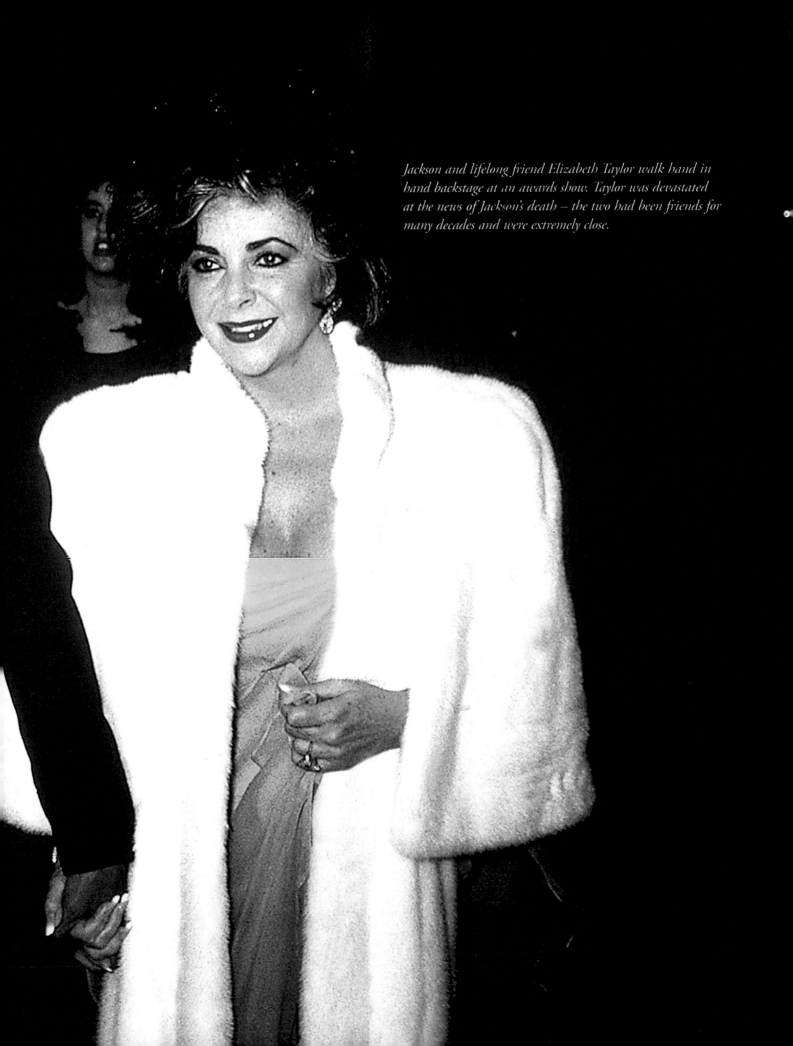

Jackson and lifelong friend Elizabeth Taylor walk hand in hand backstage at an awards show. Taylor was devastated at the news of Jackson's death – the two had been friends for many decades and were extremely close.

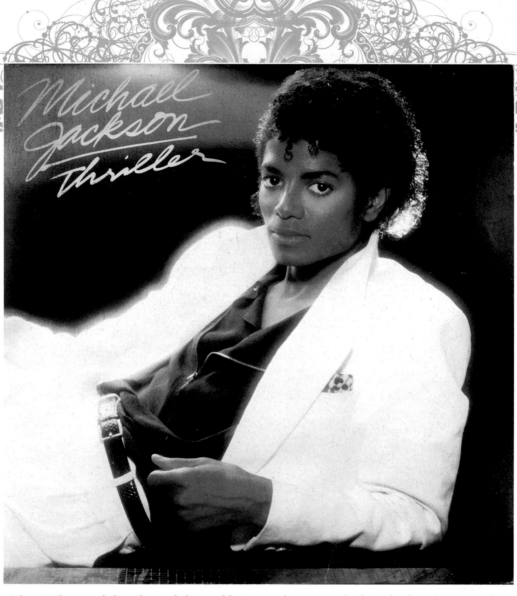

(above) The record that changed the world. Seemingly everyone had Michael staring up at them from the cover of Thriller, *and the numbers back it up – some estimates put* Thriller *sales at more than 100 million worldwide.*

(opposite) Michael wears his soon-to-be-famous red leather jacket at a musical opening in 1983. Thriller *was just beginning its rise.*

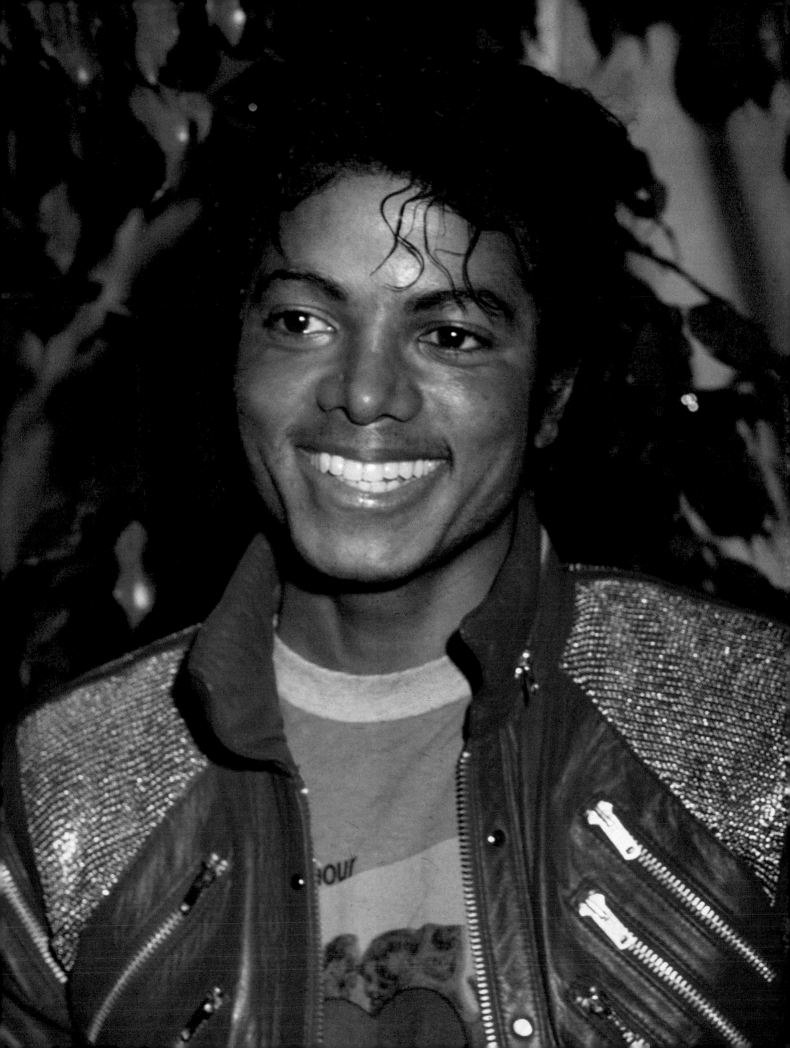

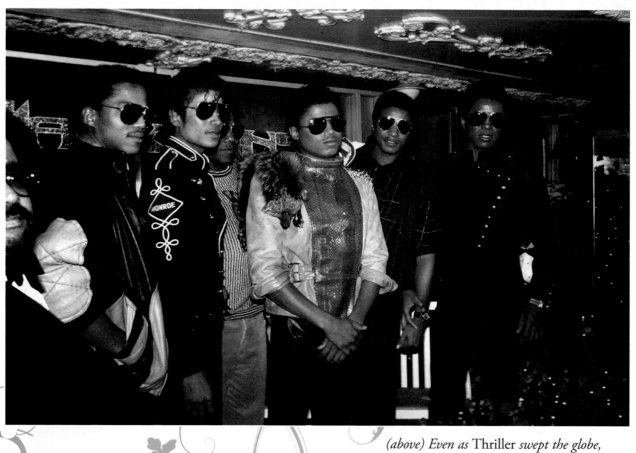

(above) Even as Thriller *swept the globe, Michael remained loyal to his family. The Jacksons continued to record and tour, and they pose here in 1983 in support of their upcoming record* Victory. *It sold well, debuting at number four on the Billboard 200 and spawned a pair of hit singles.* Victory *was the last Jacksons album to feature Michael, and the only one with all six brothers: Jermaine was back after nine years as a solo artist and Randy was a full-fledged member of the band.*

(opposite) Michael performs on stage during his Bad *World Tour in Tokyo, Japan, in September 1987.*

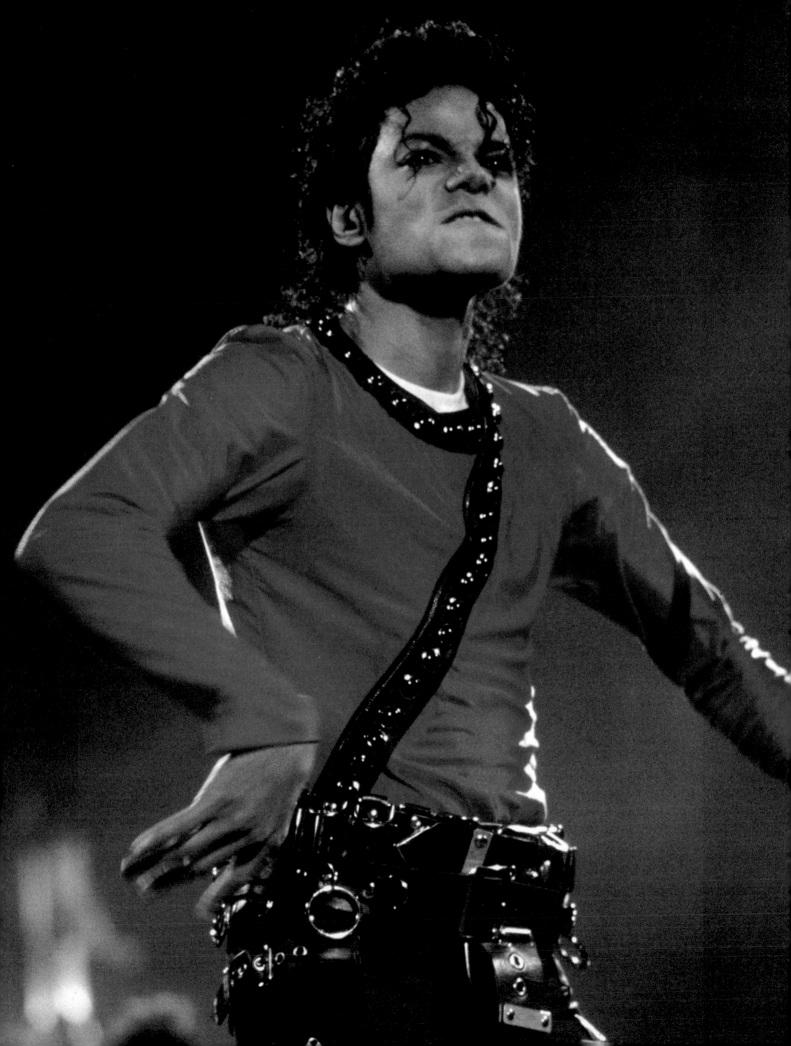

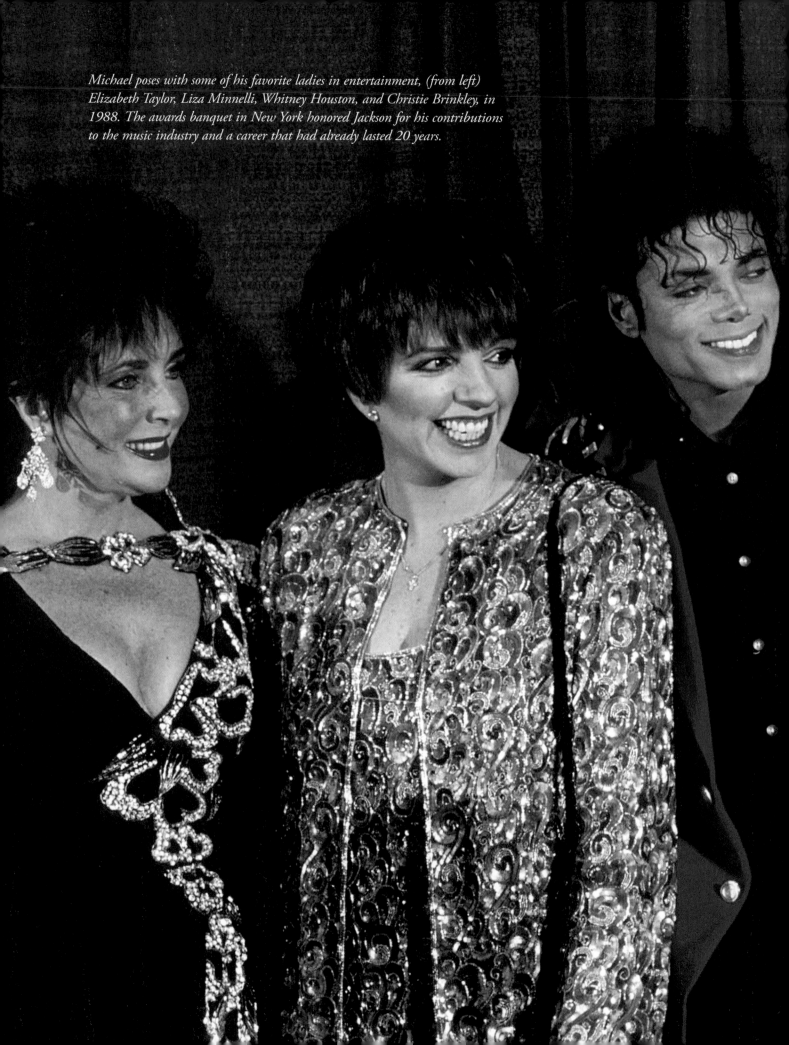

Michael poses with some of his favorite ladies in entertainment, (from left) Elizabeth Taylor, Liza Minnelli, Whitney Houston, and Christie Brinkley, in 1988. The awards banquet in New York honored Jackson for his contributions to the music industry and a career that had already lasted 20 years.

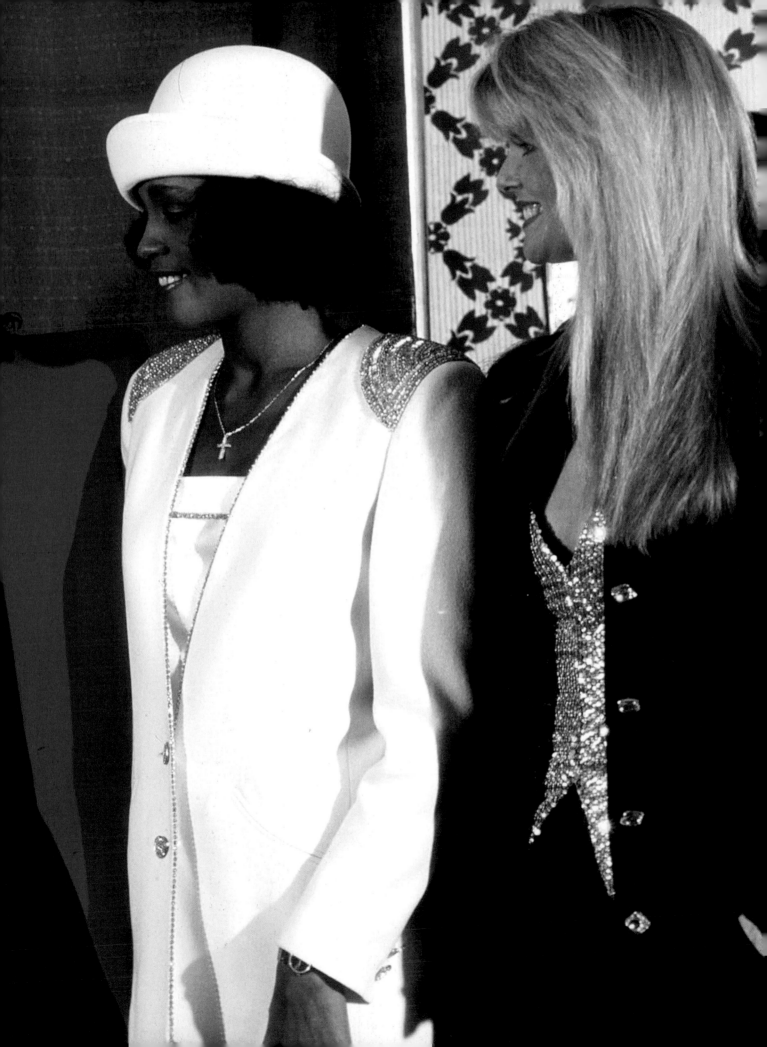

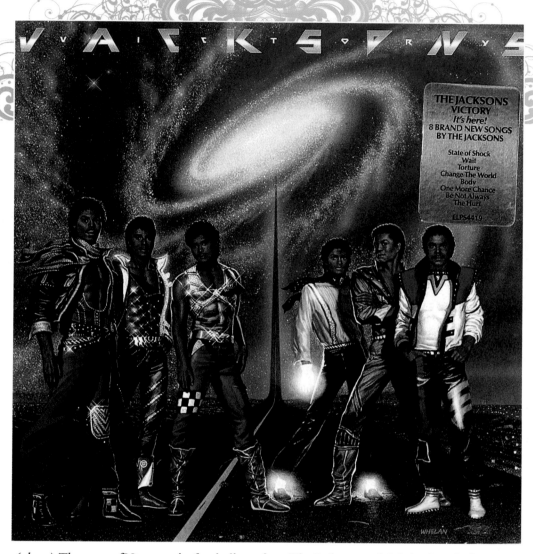

(above) The cover of Victory, *the final album from The Jacksons with Michael in the lineup. Infighting had begun to hurt the band, and they struggled to collaborate while recording. Instead of taking a photo for the cover, famous illustrator Michael Whelan was hired to do the drawings of the six brothers.*

(opposite) Whitney Houston poses with Jackson at an awards show in 1988. Houston, a major star in her own right, was surely impressed by the aura of Michael Jackson in the late 1980s. He had sold nearly 100 million records in the decade.

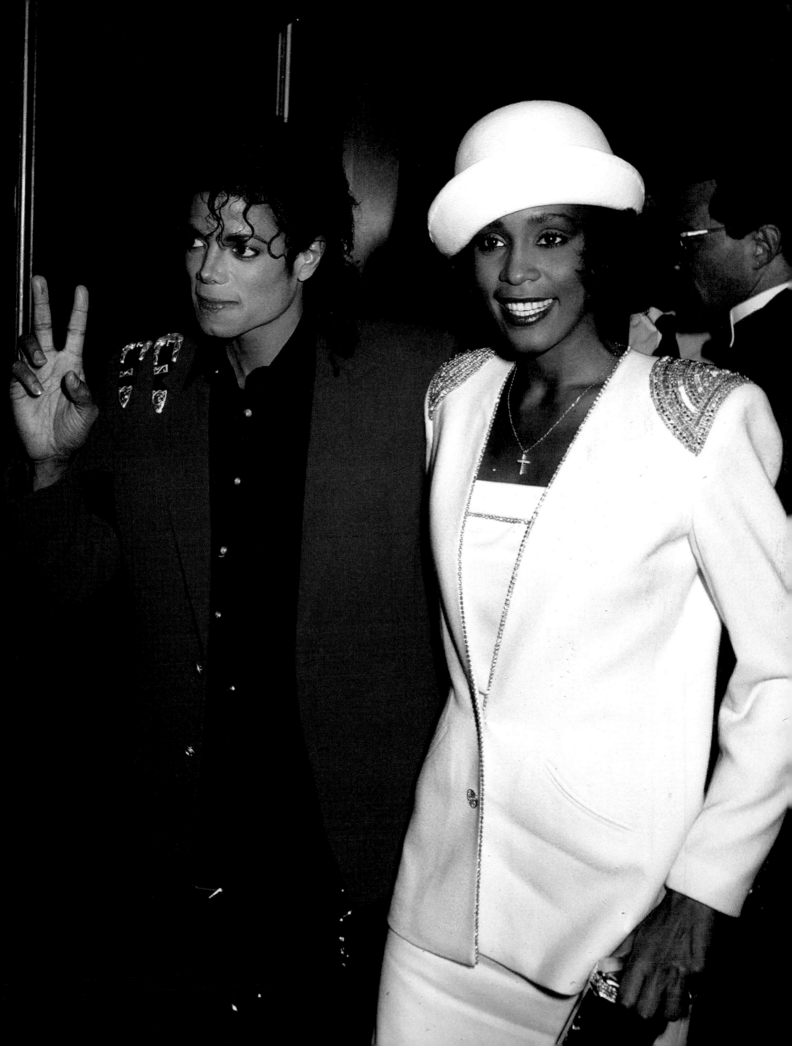



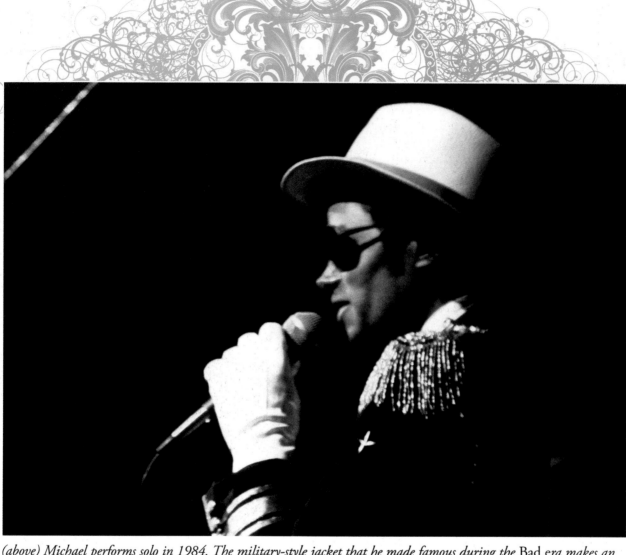

(above) Michael performs solo in 1984. The military-style jacket that he made famous during the Bad *era makes an early appearance on the singer here.*

(opposite) The outlandish style of the Bad *World Tour is on full display at Madison Square Garden in March 1988.*

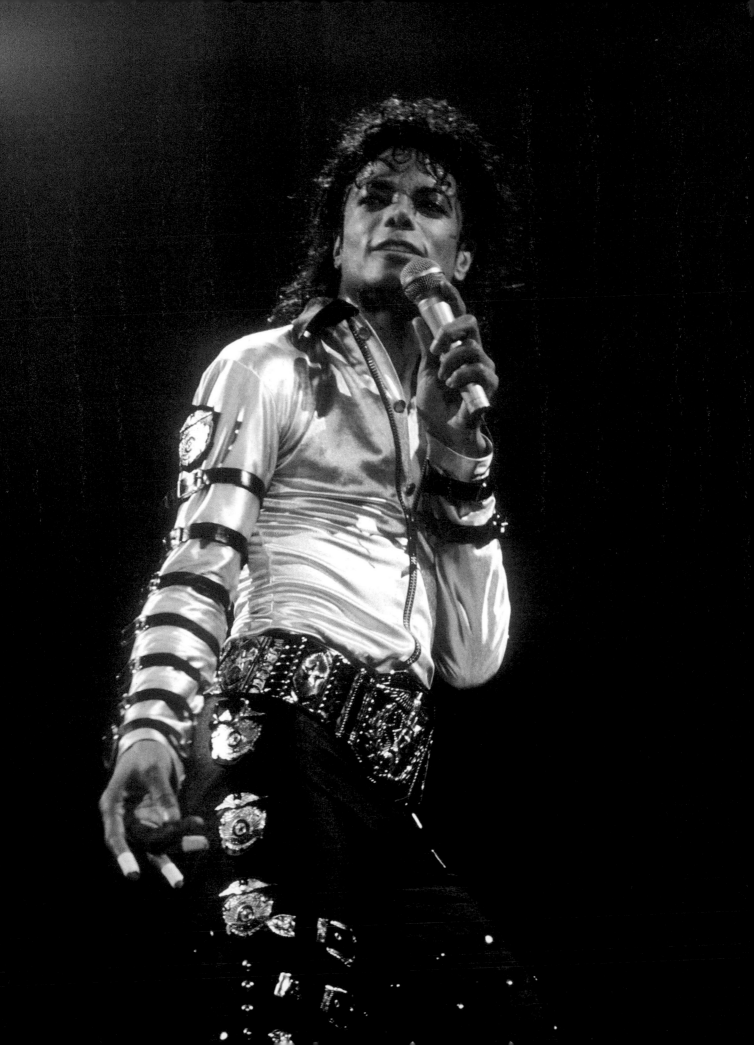

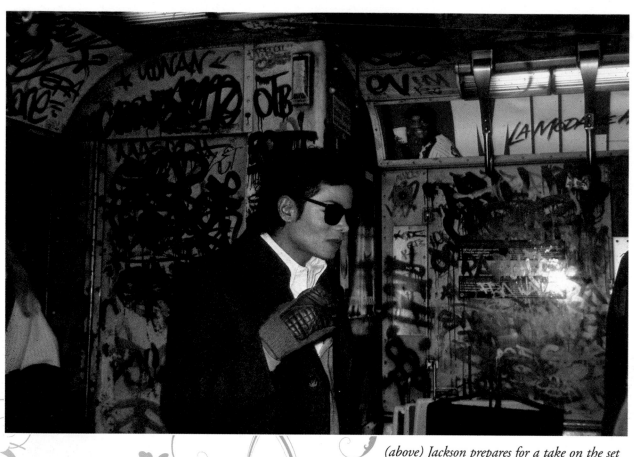

(above) Jackson prepares for a take on the set of the video for "Bad." Another in his critically acclaimed series of long-form music videos, the video owed its legacy to "Thriller" and others before it.

(opposite) The signed sheet music for the song "We Are the World" would be priceless today. The song, written by Jackson and Lionel Richie to raise awareness for a worldwide hunger problem, had some of the biggest names of the 1980s perform it. From folk singers like Paul Simon and Bob Dylan to rockers like Bruce Springsteen and Huey Lewis and pop stars like Jackson and Cyndi Lauper, many major stars made an appearance.

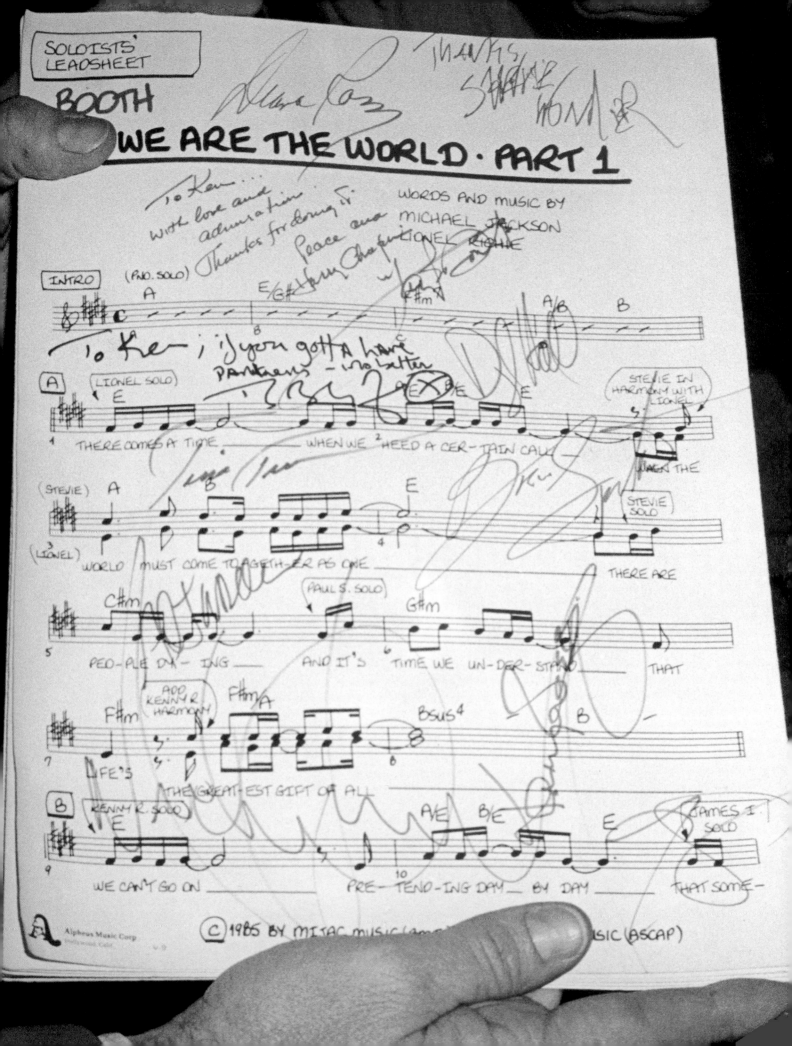

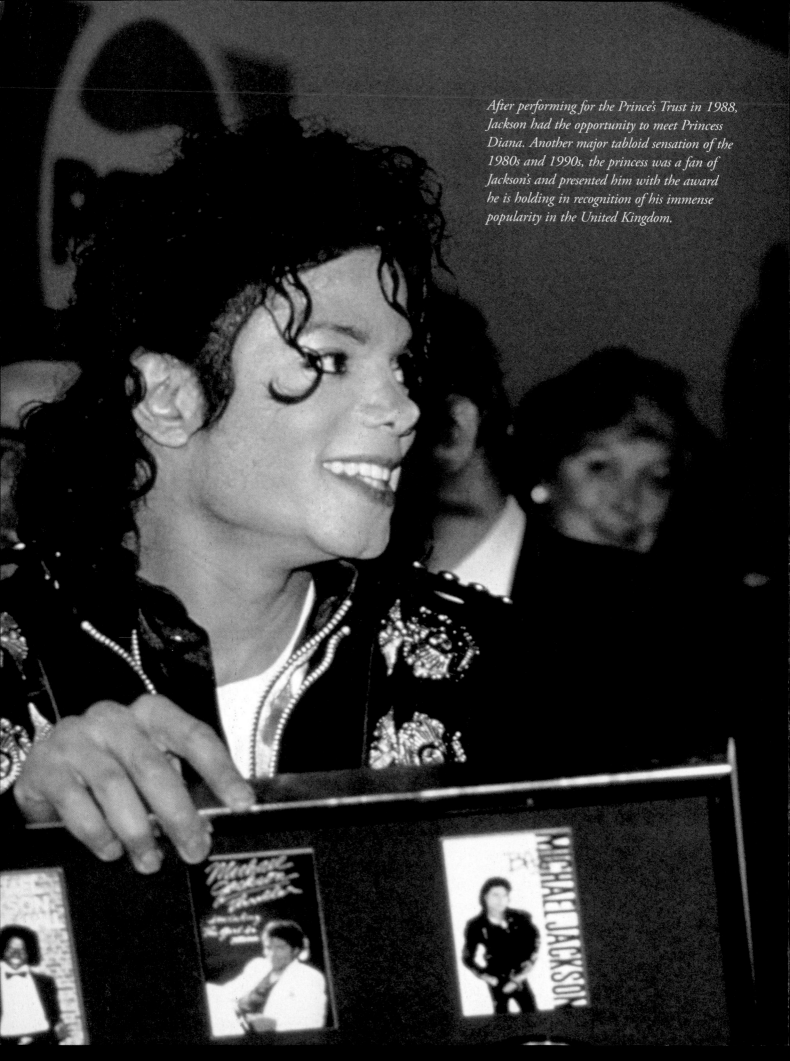

After performing for the Prince's Trust in 1988, Jackson had the opportunity to meet Princess Diana. Another major tabloid sensation of the 1980s and 1990s, the princess was a fan of Jackson's and presented him with the award he is holding in recognition of his immense popularity in the United Kingdom.

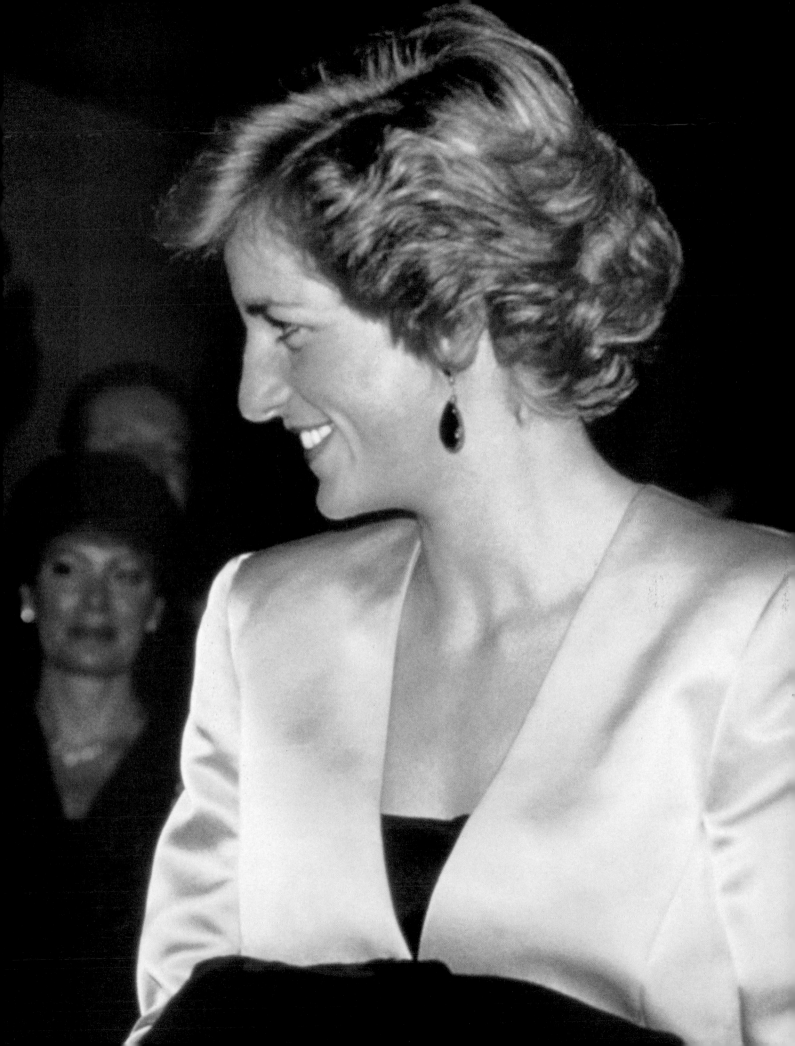

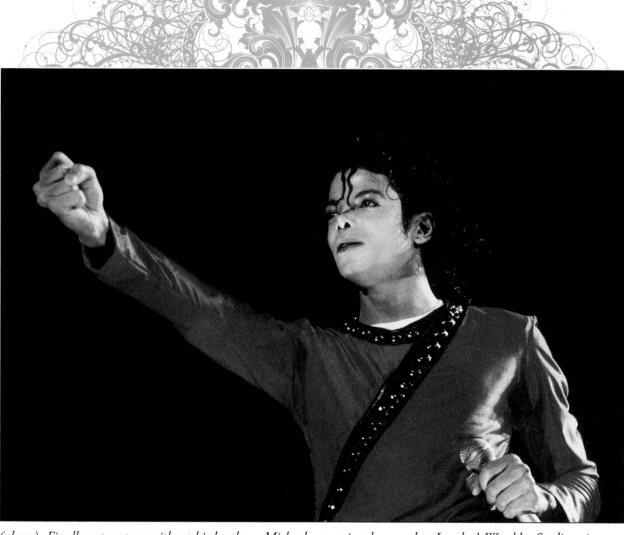

(above) Finally out on tour without his brothers, Michael entertains the crowd at London's Wembley Stadium in 1987. The tour set several world records and covered 16 months and 123 shows. Bad went to 15 countries and entertained more than 4 million fans, making it one of the most successful tours in history.

(opposite)This rare shot of Jackson in full academic regalia comes from 1988. The singer was honored at Fisk University in New York with an honorary doctorate of Humane Letters for his contributions to charity and his overall positive impact on the world.

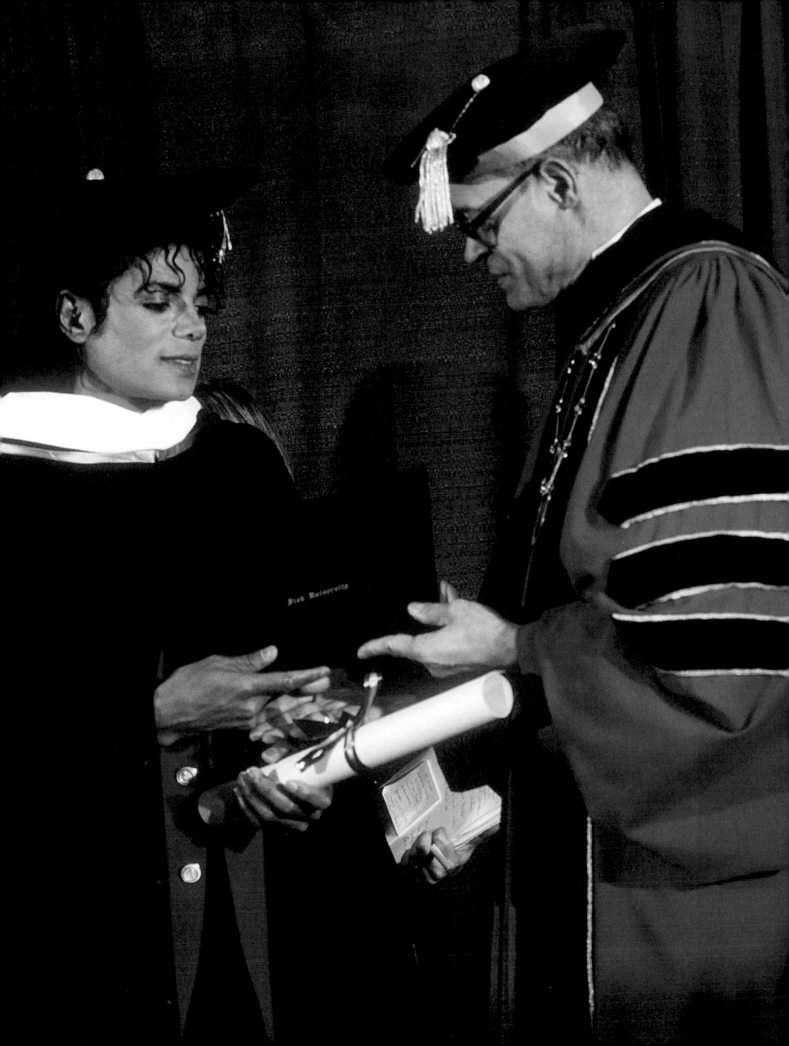

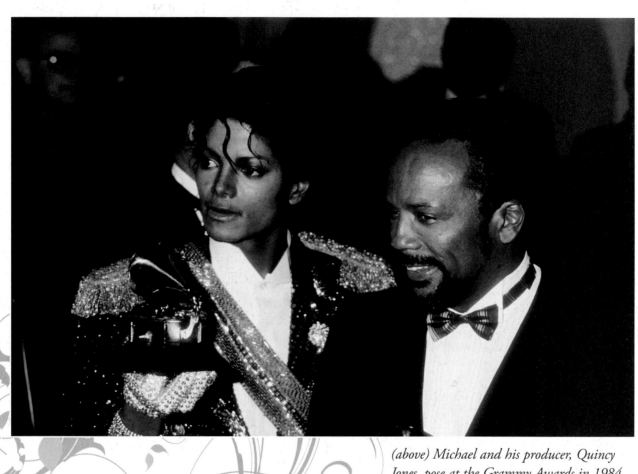

(above) Michael and his producer, Quincy Jones, pose at the Grammy Awards in 1984. Jackson and Jones had met on the set of the 1978 movie The Wiz, *collaborating musically for the first time on* Off the Wall. *They struck gold with* Thriller, *and they left the Grammys with eight awards.*

(opposite) Jackson's image was on full display on this day in London in 1984 – the suit, the single sequined white glove, and the sunglasses were all a part of a style that was unique to Jackson.

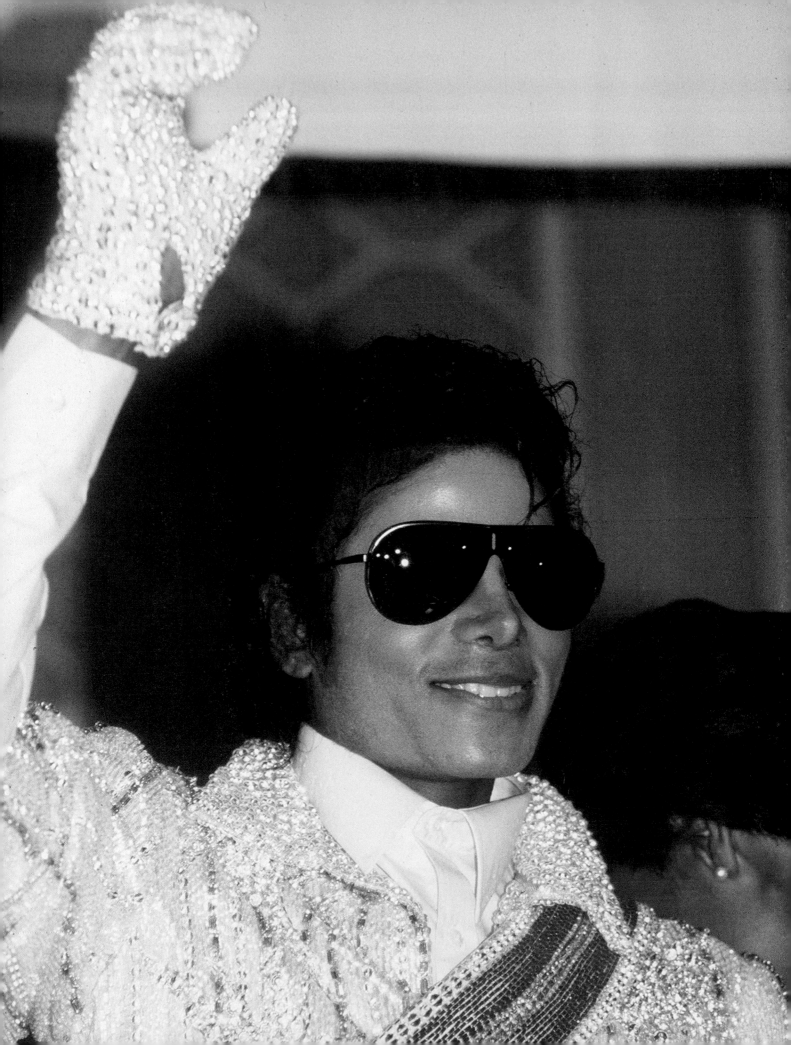

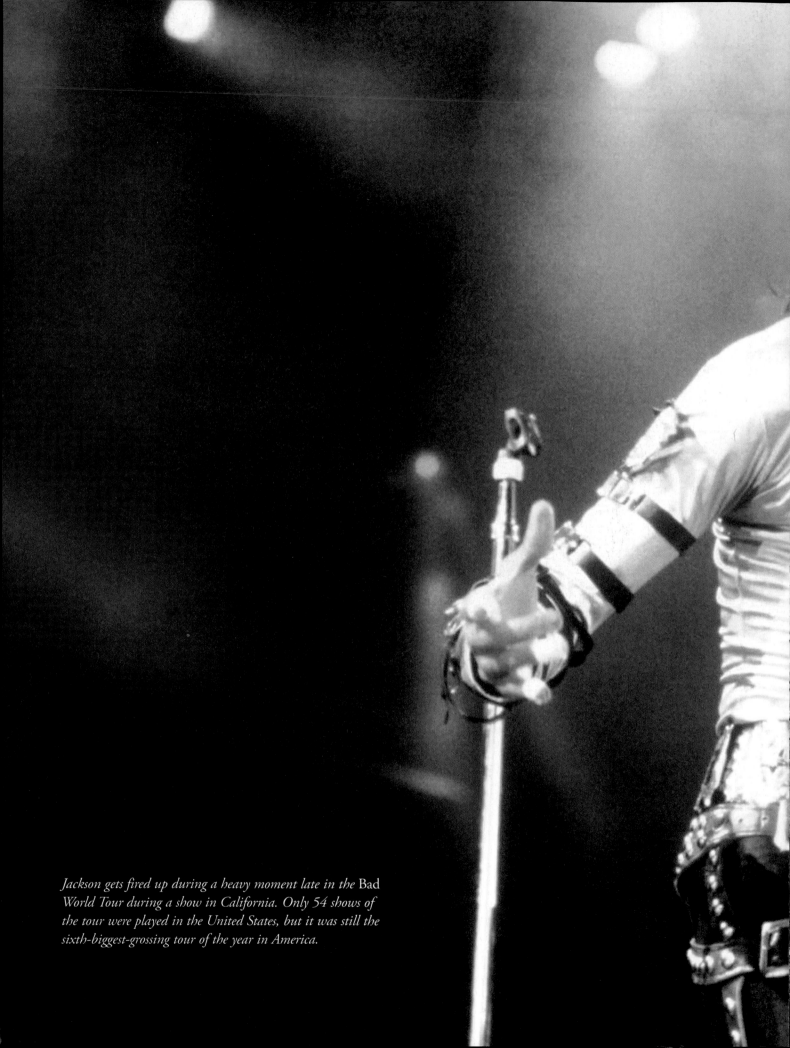

Jackson gets fired up during a heavy moment late in the Bad World Tour *during a show in California. Only 54 shows of the tour were played in the United States, but it was still the sixth-biggest-grossing tour of the year in America.*

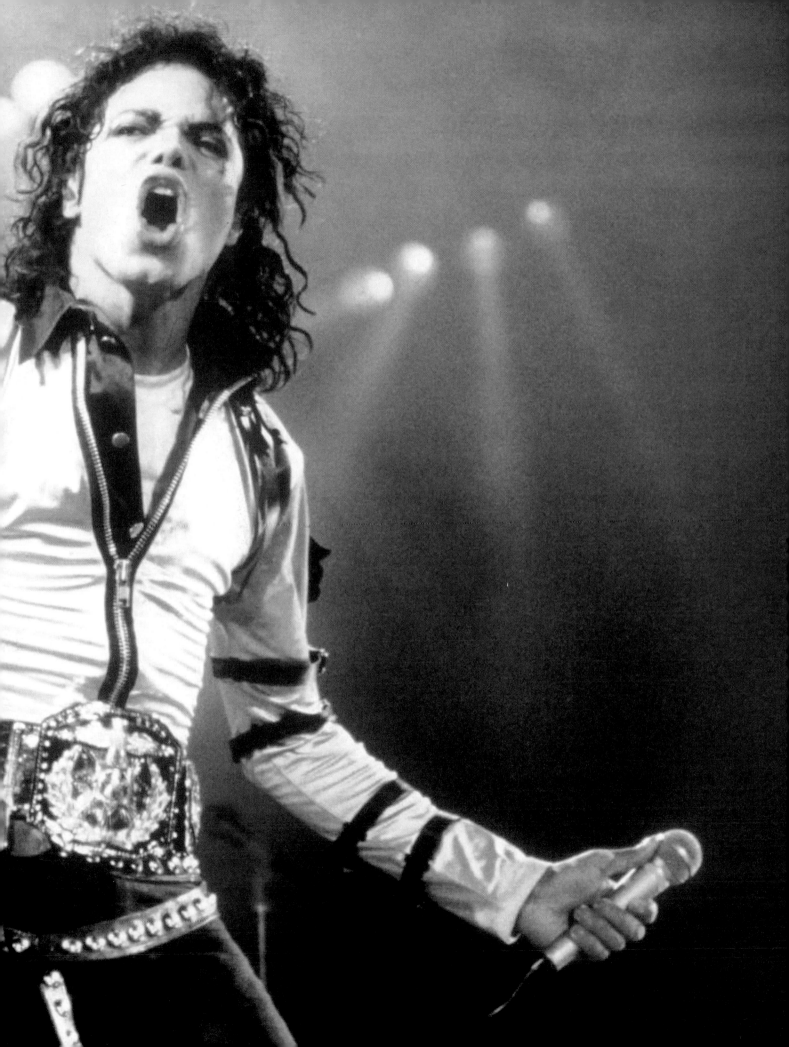

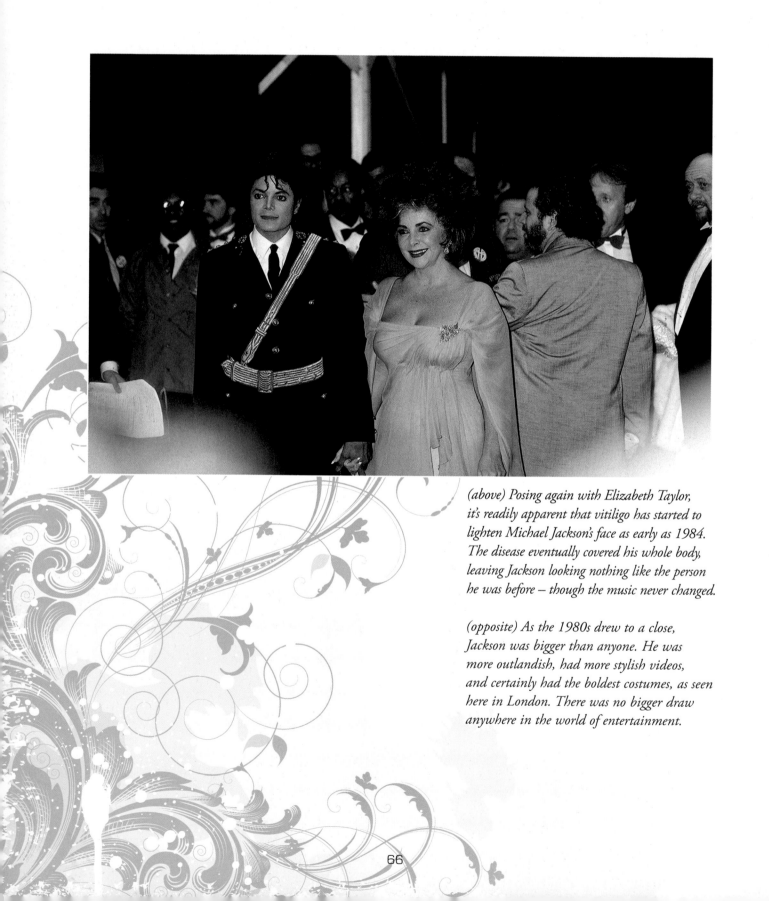

(above) Posing again with Elizabeth Taylor, it's readily apparent that vitiligo has started to lighten Michael Jackson's face as early as 1984. The disease eventually covered his whole body, leaving Jackson looking nothing like the person he was before – though the music never changed.

(opposite) As the 1980s drew to a close, Jackson was bigger than anyone. He was more outlandish, had more stylish videos, and certainly had the boldest costumes, as seen here in London. There was no bigger draw anywhere in the world of entertainment.

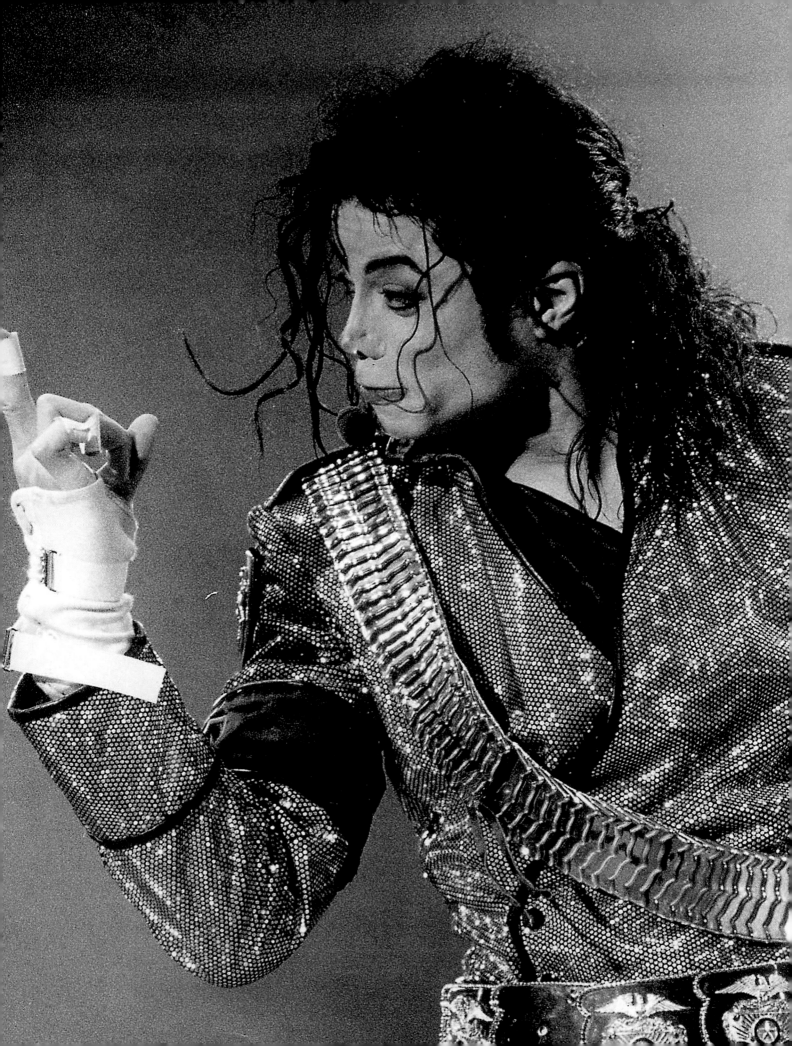

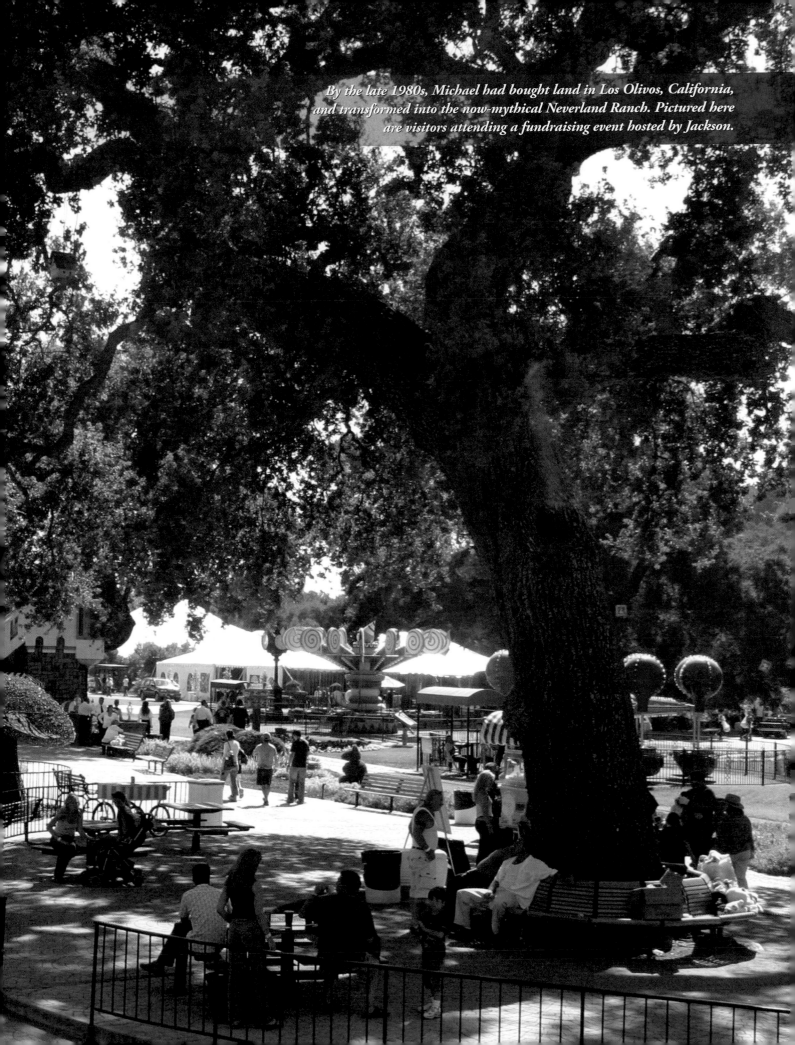

By the late 1980s, Michael had bought land in Los Olivos, California, and transformed into the now-mythical Neverland Ranch. Pictured here are visitors attending a fundraising event hosted by Jackson.

The King of POP

(opposite) It's all smiles for Michael Jackson as he collects a BMI Award in 1990. There was little doubt that the 1990s would be just as big for Jackson as the 1980s were. It certainly turned out to be an eventful decade for the singer.

After dominating pop music in the 1980s, fans and critics were excited to see what Michael Jackson had in store for the next decade. There were no albums bigger than *Thriller* and *Bad,* and Jackson seemed to be just entering his prime as an artist.

In hindsight, considering the astonishing heights he hit in the 1980s, maybe there was nowhere to go but down. On top of the world professionally, his personal affairs increasingly came under the microscope and seemed to gradually bleed the life and vibrancy out of the mercurial artist.

The new decade started off with Jackson in the studio, recording his new album, *Dangerous.* Jackson had recently signed a 15-year, six-record deal with Sony, and if the singer was able to deliver sales numbers comparable to what he posted in the 1980s, the deal was estimated to have an earning power of up to $1 billion.

Dangerous got off to a great start—it debuted at number one and quickly outpaced the sales of

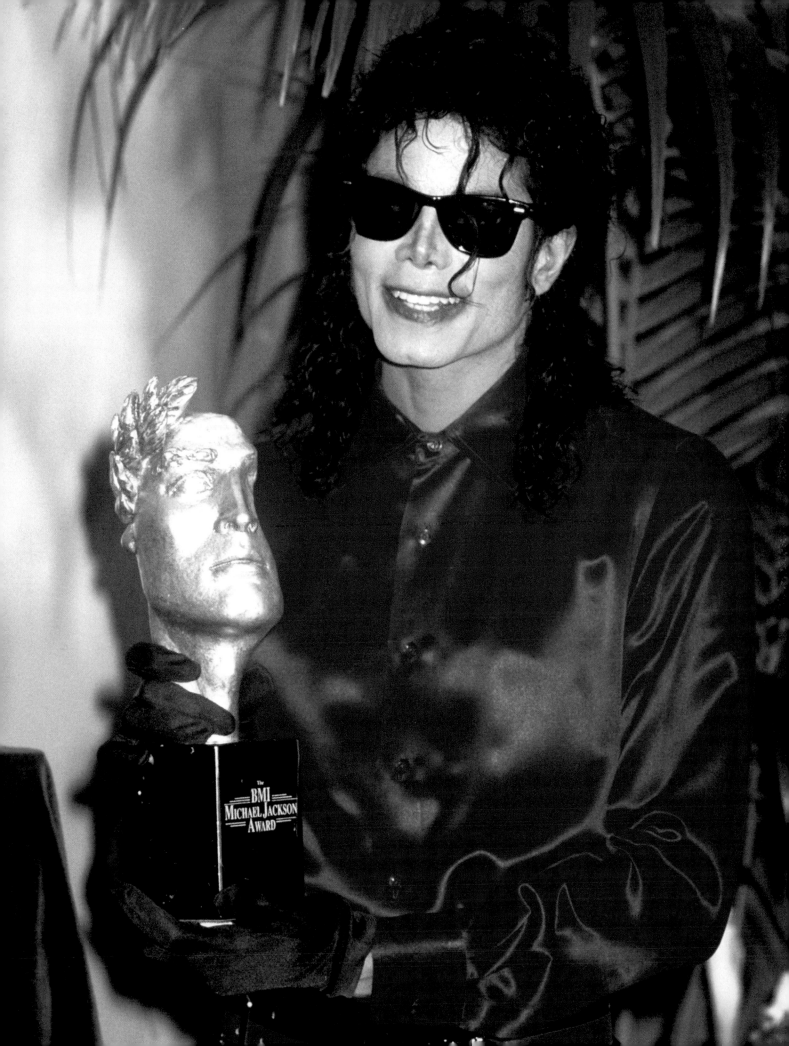

The
BMI
MICHAEL JACKSON
AWARD

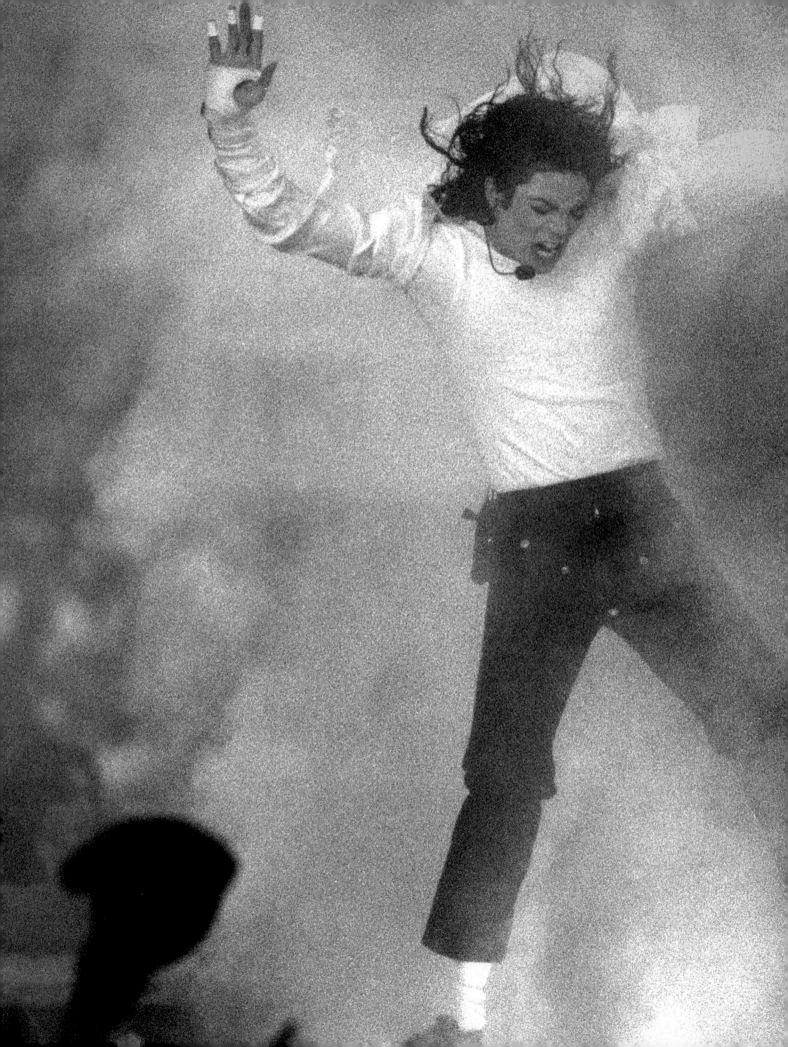

Jackson never performed for a bigger audience than on Super Bowl Sunday in 1993. An estimated 125 million people watched in the United States alone, with hundreds of millions watching around the world. It was the first time ratings for the halftime show were higher than for the game itself.

Bad. To date, the record has sold more than 30 million copies around the world, including 7 million in the United States. It was Jackson's fastest-selling record ever, moving 4 million units in only two months.

The record was even bigger worldwide—Jackson had become an international superstar thanks to his epic live shows, and the hard work he put into his live perform-ances was paying dividends and making him a global phenomenon. In the United Kingdom, the record debuted at number one and spent a total of 96 weeks in the top 75. It remains one of the best-selling albums in British history. The record also sold particularly well in Asia and South America, further illustrating Jackson's global appeal.

Nine singles were eventually released off *Dangerous,* seven of which reached the Top Ten in both Britain and the United States. "Black or White" featured a revolution-ary music video, and other tracks like "In the Closet," "Remember the Time," and "Will You Be There" all were major hits.

Jackson's star was growing ever brighter, something that seemed impossible considering his mind-boggling climb to stardom. On a visit to the Ivory Coast in Africa, he was even crowned as king by a tribal chief. Back at home, Jackson put on what many consider to be the seminal performance of his career during an electric four-song set at halftime of Super Bowl XXVII, which was seen by 150 million people in the United States alone.

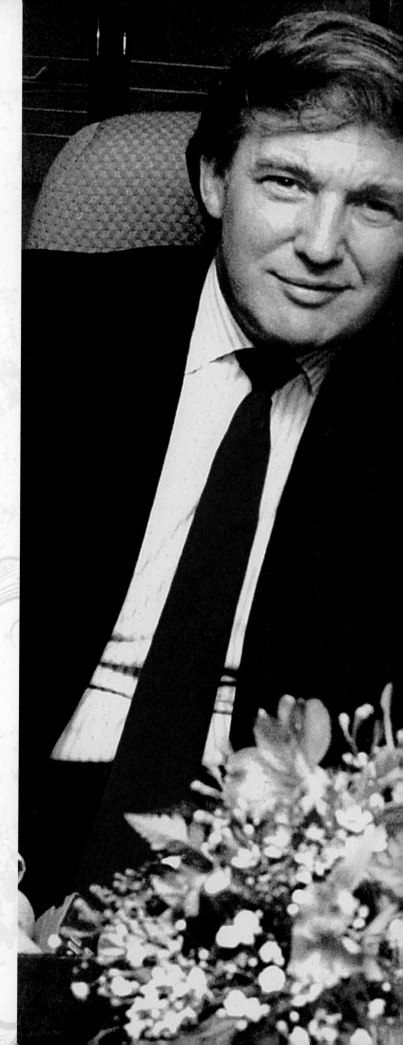

On a private plane ride, Jackson and billionaire Donald Trump take a moment to pose for the camera. The two were making a charitable visit in 1990 to visit famous AIDS patient Ryan White, who had become a poster child for the disease.

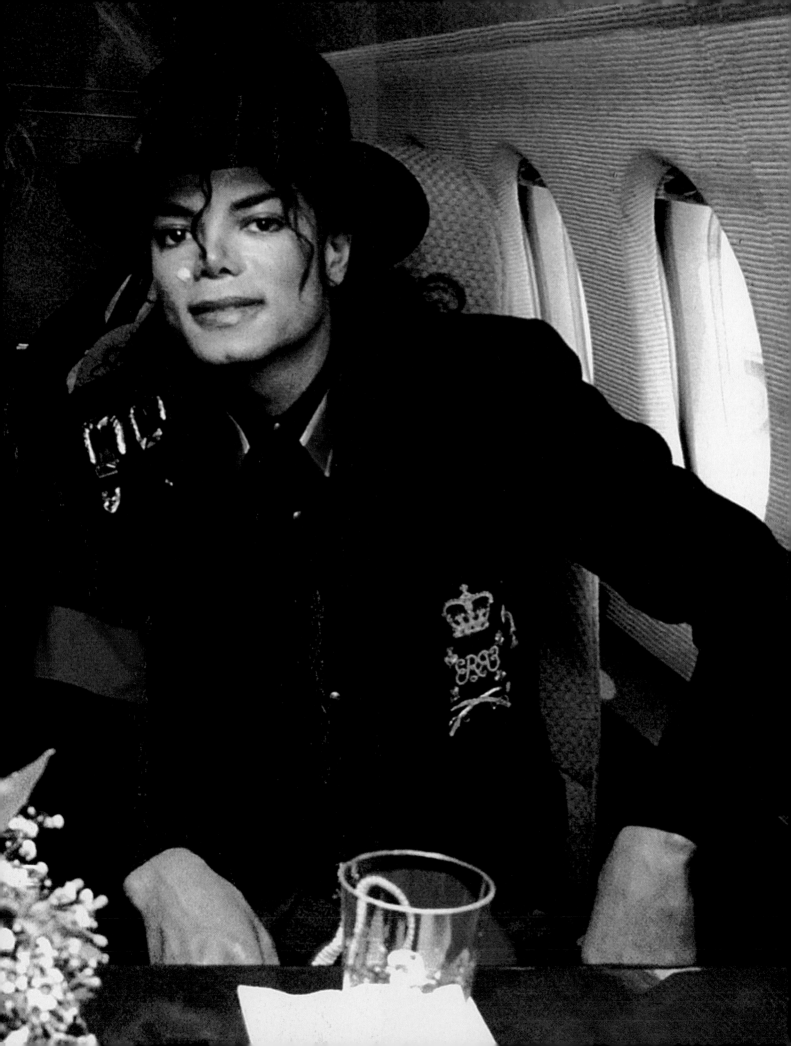

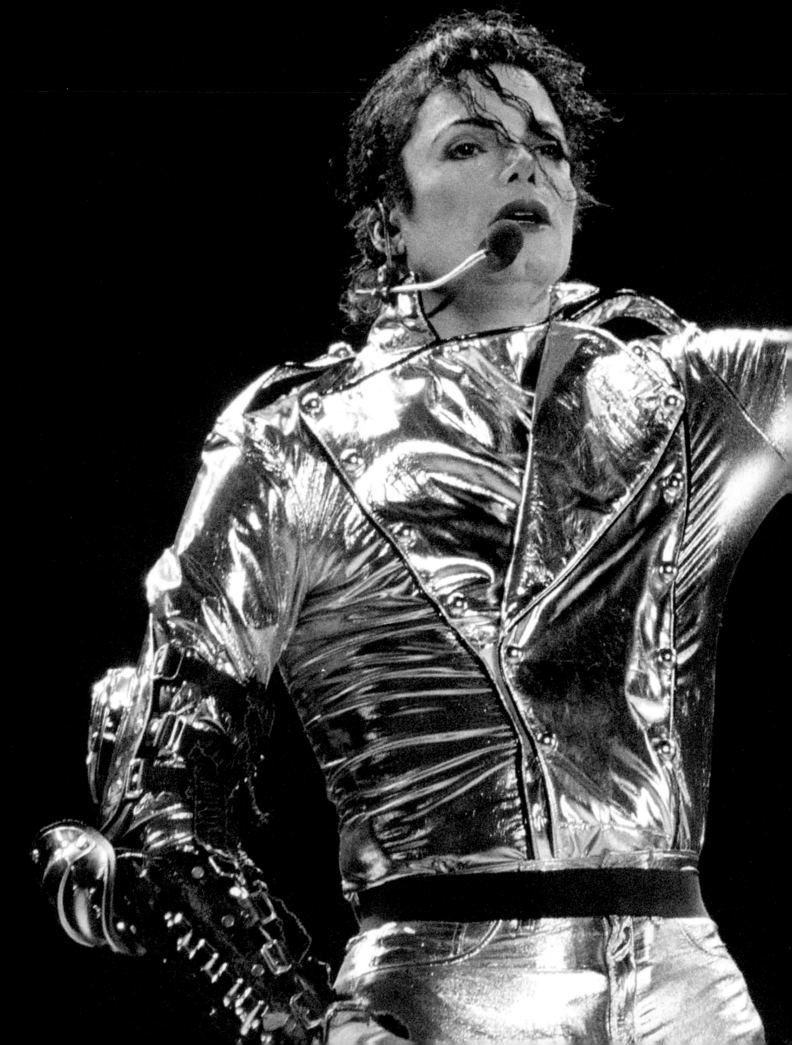

Taking the stage in support of HIStory, *his combination greatest hits/new material double album, Jackson's show was as refined as ever. He had kicked off the tour with a show played at a private gathering for the Sultan of Brunei in the Middle Eastern nation where Jackson lived in the 2000s.*

After legal allegations slowed Jackson down, the singer was ready to roar back onto the scene with 1995's *HIStory.* A unique double album, the first disc contained a greatest hits collection of Jackson's last 15 years in pop while the second disc featured new songs, bridging the past and present.

The new tracks featured a more raw and emotional Jackson than the slick pop records of the past—Jackson seemed to be getting worn out by years in the brightest of spotlights and tired of allegations and the tabloid reporting on his marriage to Lisa Marie Presley. Featuring singles including "Scream," a duet with his little sister Janet, the record generated buzz in the media. The 20 million copies the record has sold make it the best-selling double album of all time. The resulting world tour was Jackson's most successful, as he played in front of 4.5 million fans in 35 countries.

Jackson began a gradual retreat from the public eye as the 1990s drew to a close. Sony continued to issue mix and compilation albums of Jackson's work, including *Blood on the Dance Floor: HIStory in the Mix,* which also went platinum. But Jackson also became a father in the 1990s and began to spend more time at home with his family. Though the decade began with a bang, Jackson's music and mentality were undergoing fundamental changes as he headed into the new millennium. ★

The HIStory *Tour was big, just like all of Jackson's world tours. This stop filled London's Wembley Stadium for an incredible concert event. Over 82 shows, the tour pulled in 4.5 million fans and grossed over $160 million. Only two shows were played in the United States: a pair at Honolulu's Aloha Stadium. The tour never made it to the mainland, but Jackson did not miss a beat in putting on one of the best tours of the 1990s.*

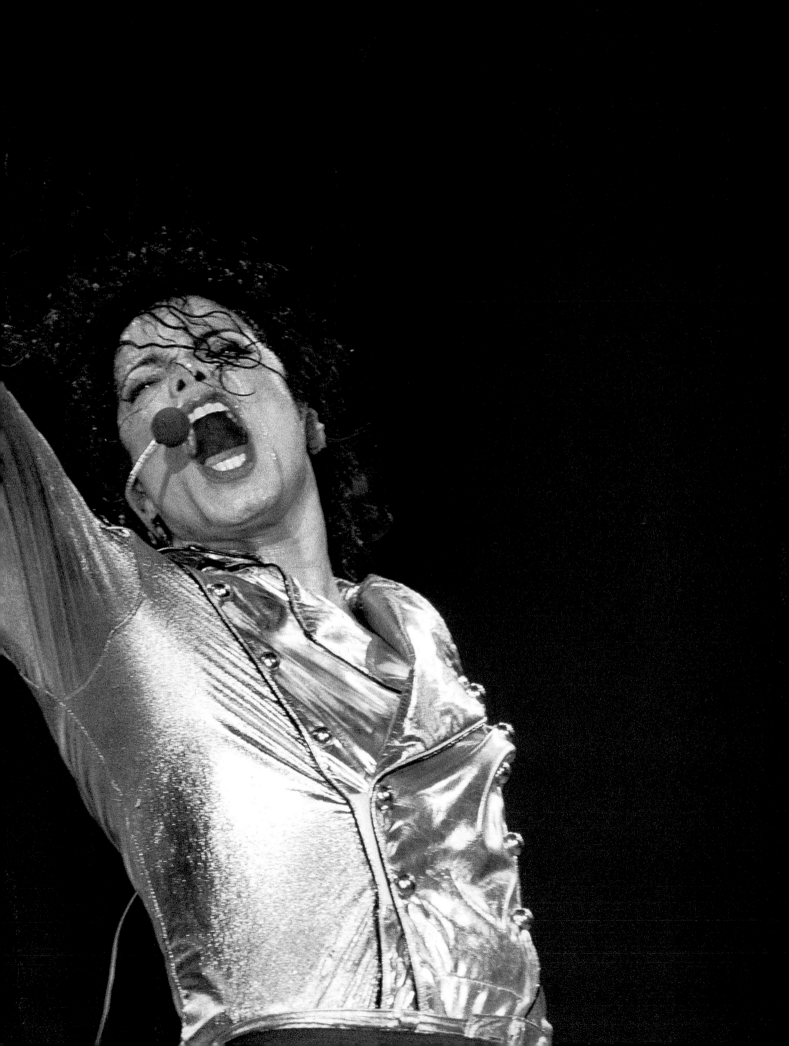

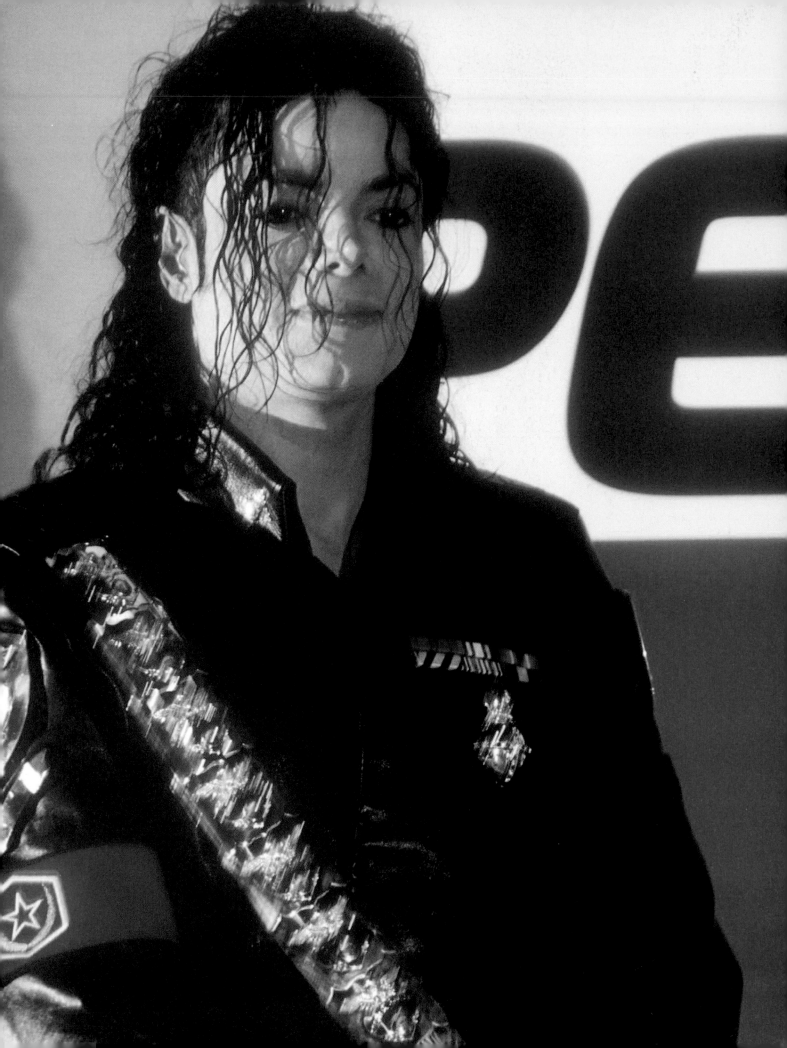

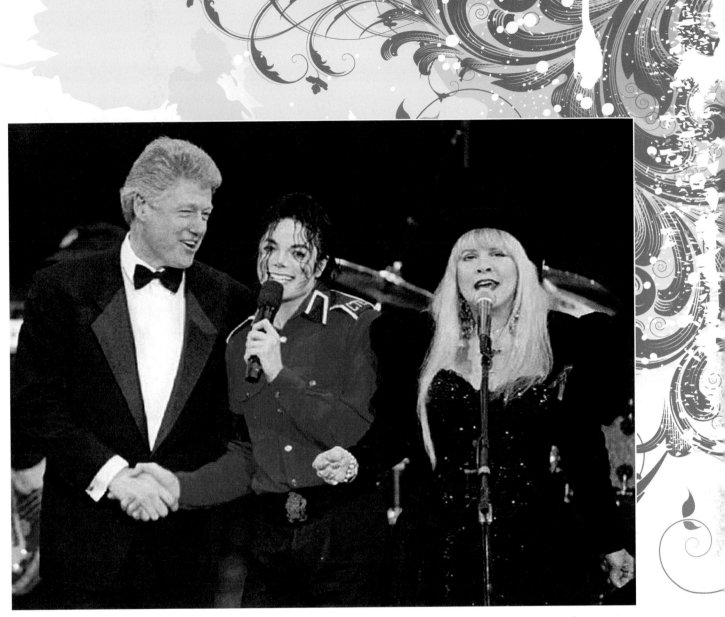

(above) A new president, another meeting. Michael met President Bill Clinton as soon as the new commander in chief arrived in Washington in 1993. He performed at one of the inaugural balls alongside former Fleetwood Mac singer Stevie Nicks, pictured at right.

(opposite) Jackson poses in 1992 at a press conference for Pepsi. He had been a spokesperson for the brand since 1982, and one of the most notable incidents of his career took place during the filming of a commercial for the product. In 1983, while camera crews were filming a fake concert for a television spot, a botched pyrotechnic effect lit Jackson on fire, requiring him to be rushed to the hospital with burns.

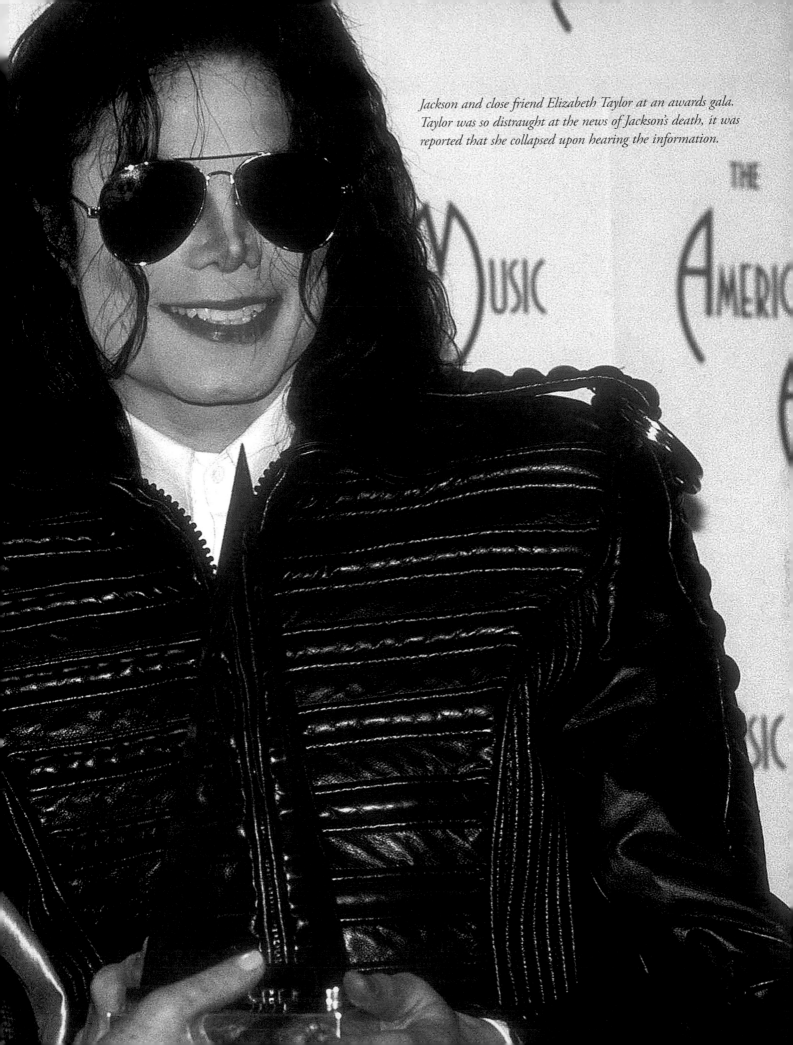

Jackson and close friend Elizabeth Taylor at an awards gala. Taylor was so distraught at the news of Jackson's death, it was reported that she collapsed upon hearing the information.

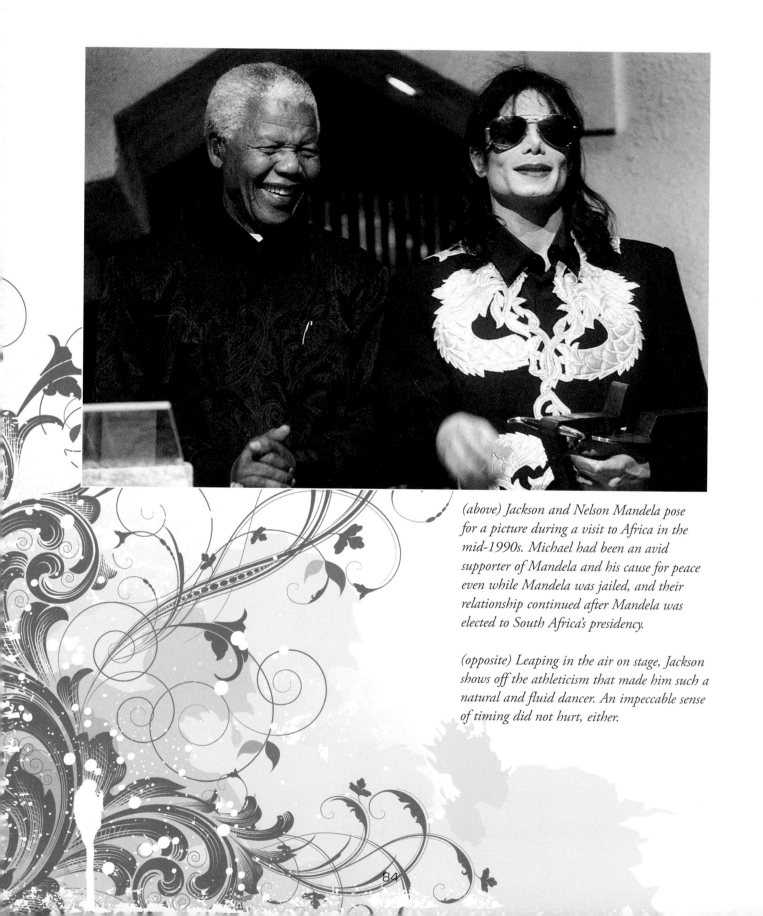

(above) Jackson and Nelson Mandela pose for a picture during a visit to Africa in the mid-1990s. Michael had been an avid supporter of Mandela and his cause for peace even while Mandela was jailed, and their relationship continued after Mandela was elected to South Africa's presidency.

(opposite) Leaping in the air on stage, Jackson shows off the athleticism that made him such a natural and fluid dancer. An impeccable sense of timing did not hurt, either.

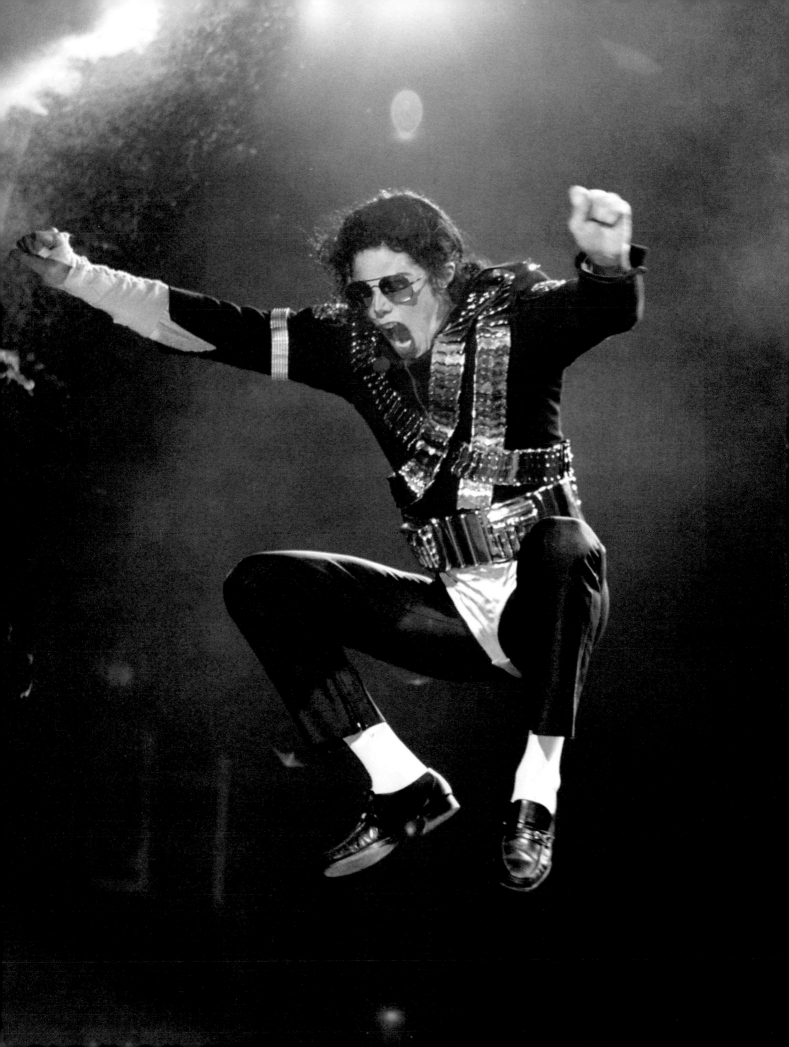

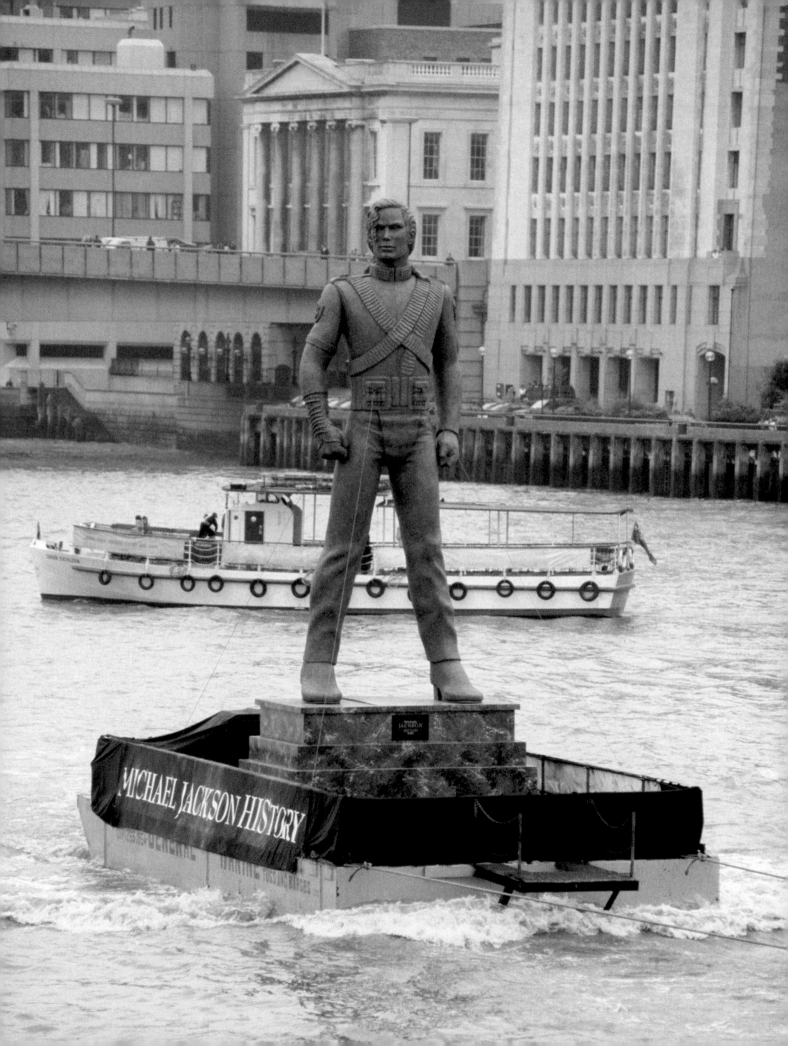

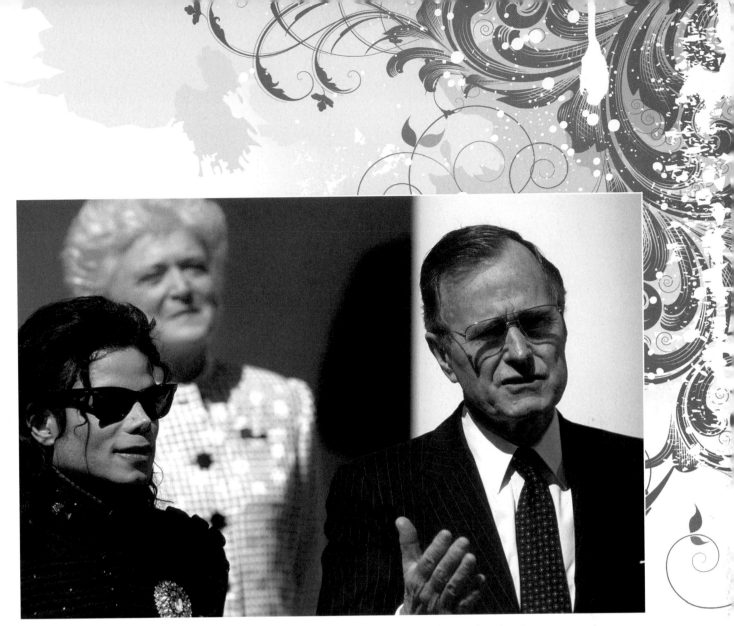

(above) Jackson kicked off the 1990s in part by collecting accolades from the previous decade. He was invited to meet yet another president in the summer of 1990 when George H.W. Bush honored Jackson as the "Entertainer of the Decade" at the Museum of Children.

(opposite) In support of the launch of HIStory, Jackson and the Sony PR machine contracted the construction of statues to be placed strategically around the world as a promotion. This particular statue is being towed through central London on the River Thames.

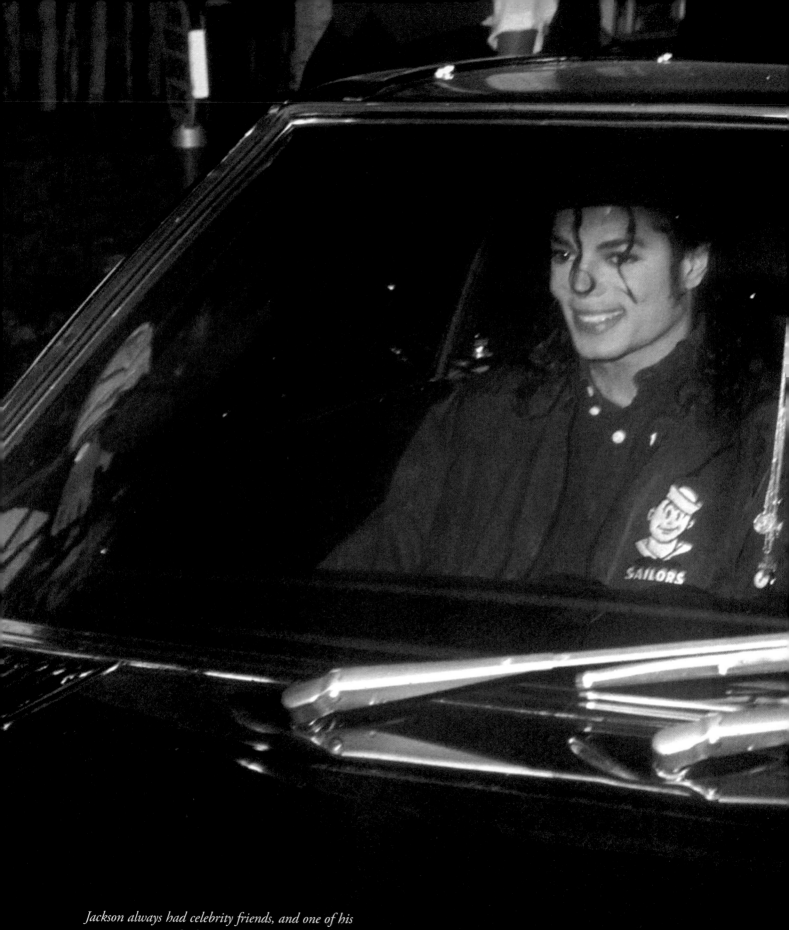

Jackson always had celebrity friends, and one of his companions was the biggest female star of the 1980s and 1990s, Madonna. They are shown riding in the car together after an awards show.

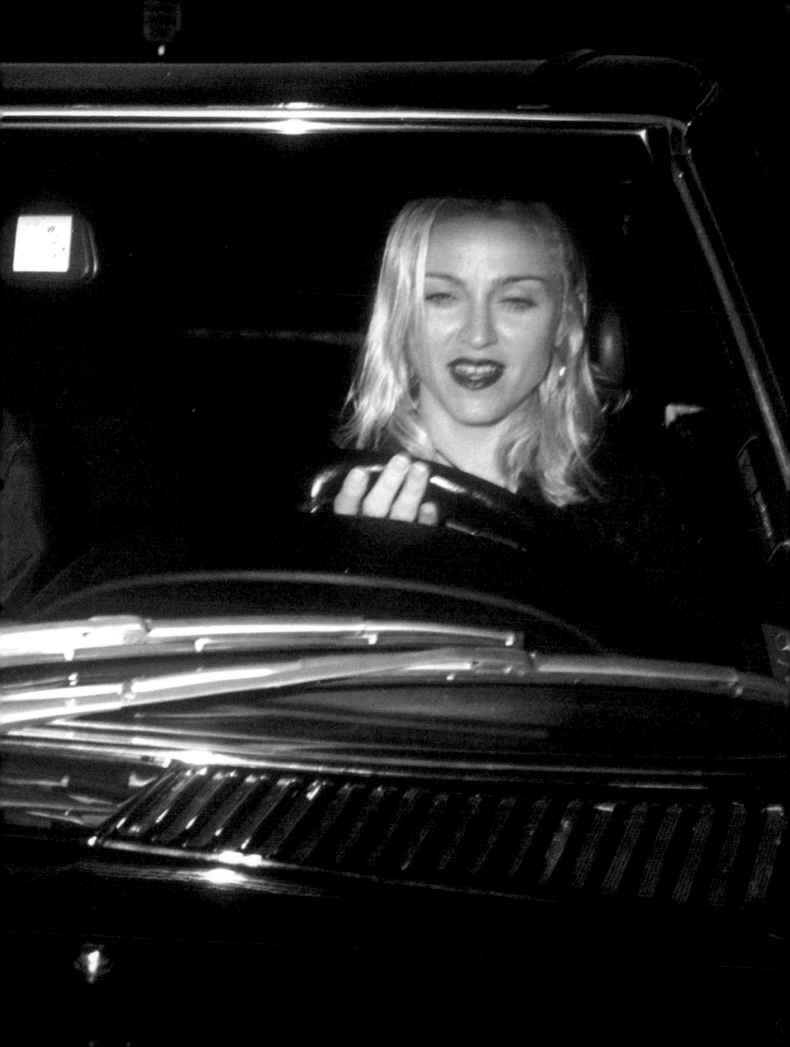

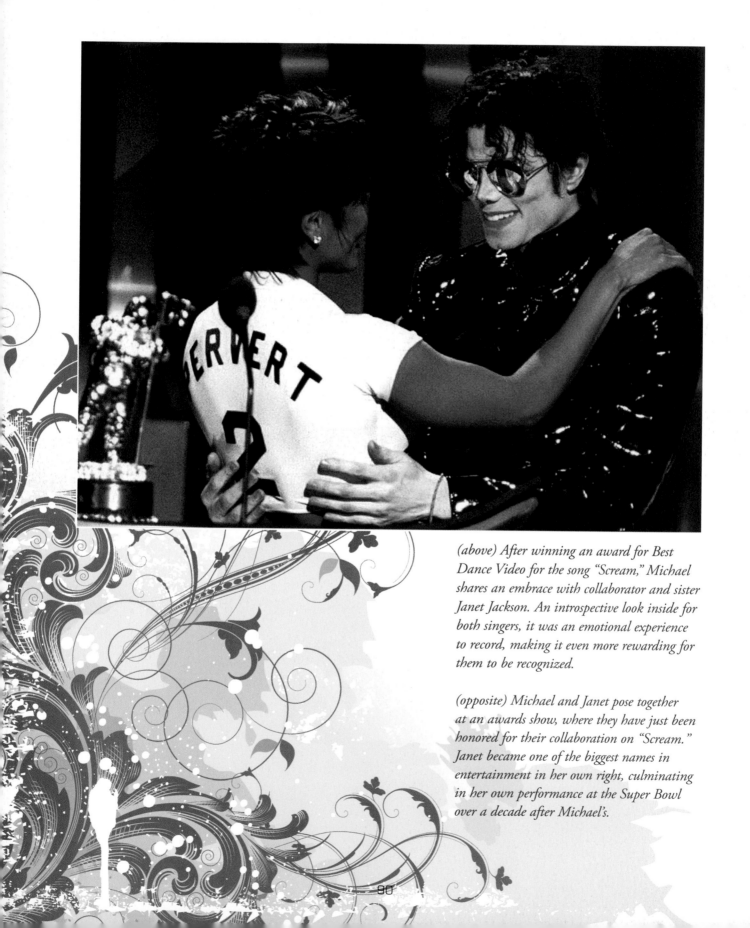

(above) After winning an award for Best Dance Video for the song "Scream," Michael shares an embrace with collaborator and sister Janet Jackson. An introspective look inside for both singers, it was an emotional experience to record, making it even more rewarding for them to be recognized.

(opposite) Michael and Janet pose together at an awards show, where they have just been honored for their collaboration on "Scream." Janet became one of the biggest names in entertainment in her own right, culminating in her own performance at the Super Bowl over a decade after Michael's.

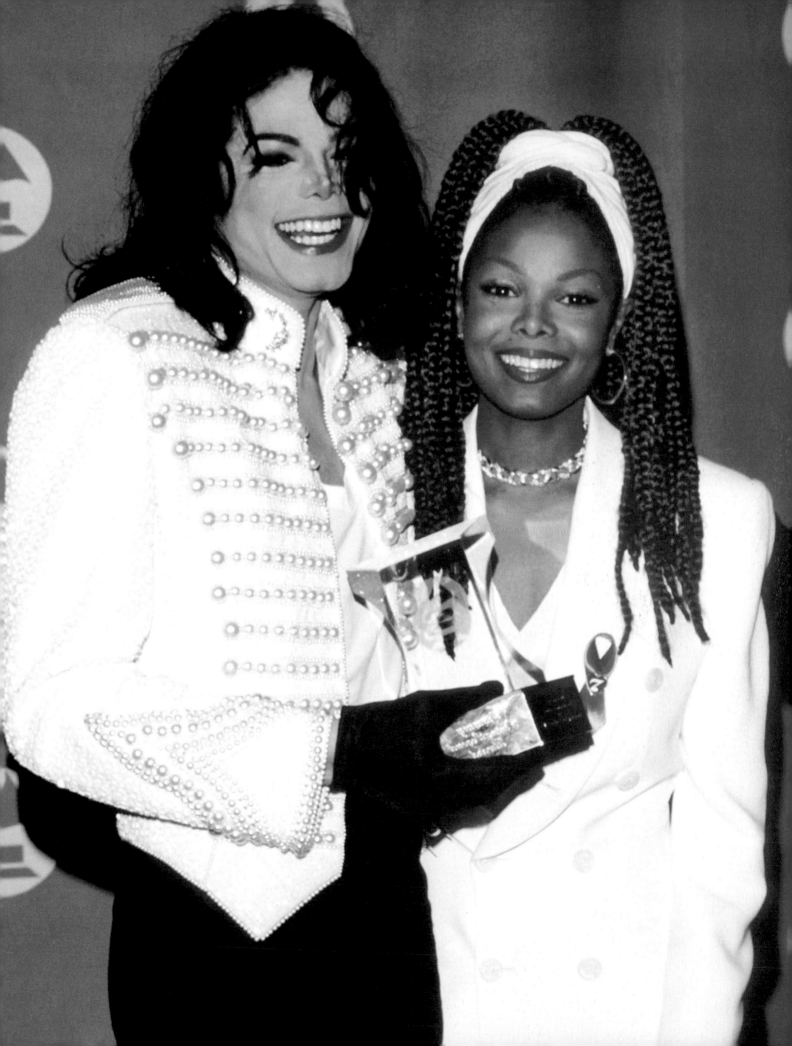

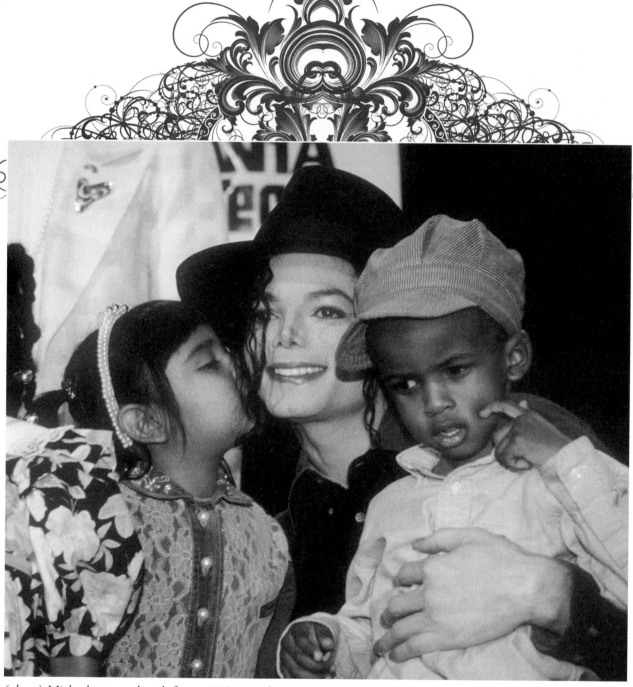

(above) Michael appeared with former U.S. President Jimmy Carter and his wife Rosalynn to meet a group of children in May 1993 in Atlanta, Georgia. Jackson joined Carter and his wife for the Atlanta Project's "Kid's Celebration," a concert that promoted vaccinations for Atlanta's urban youth.

(opposite) Jackson performs at the 12th annual MTV Movie Awards at Radio City Music Hall in New York City on September 7, 1995.

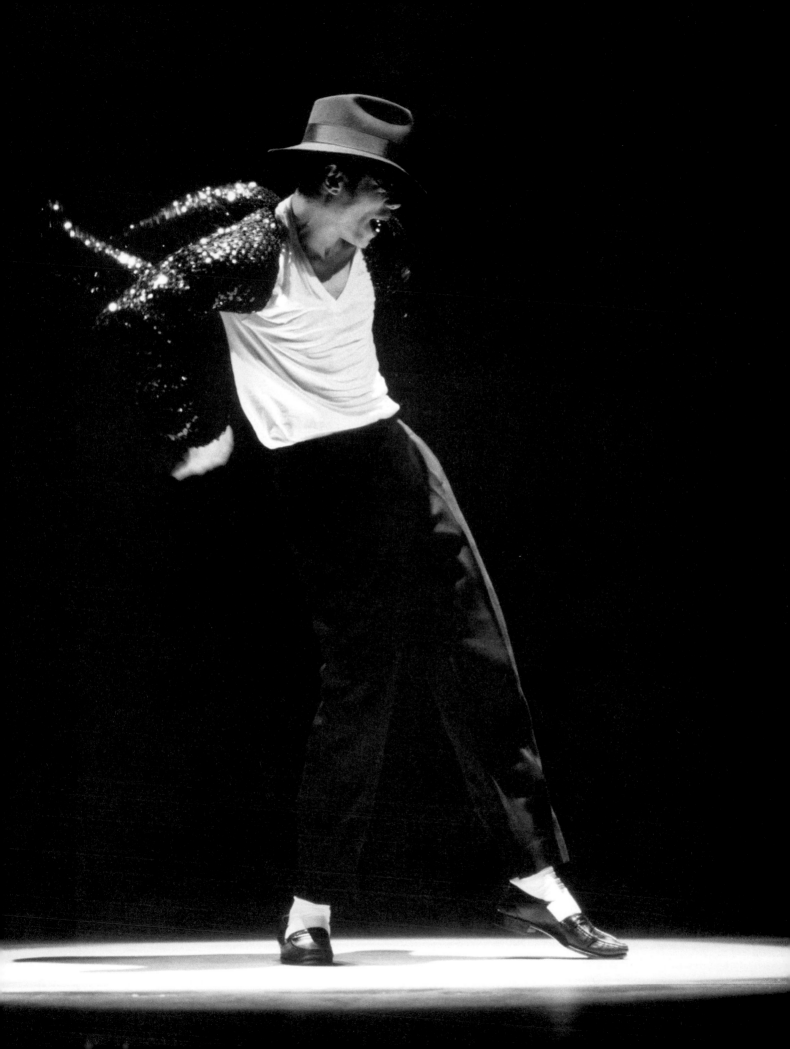

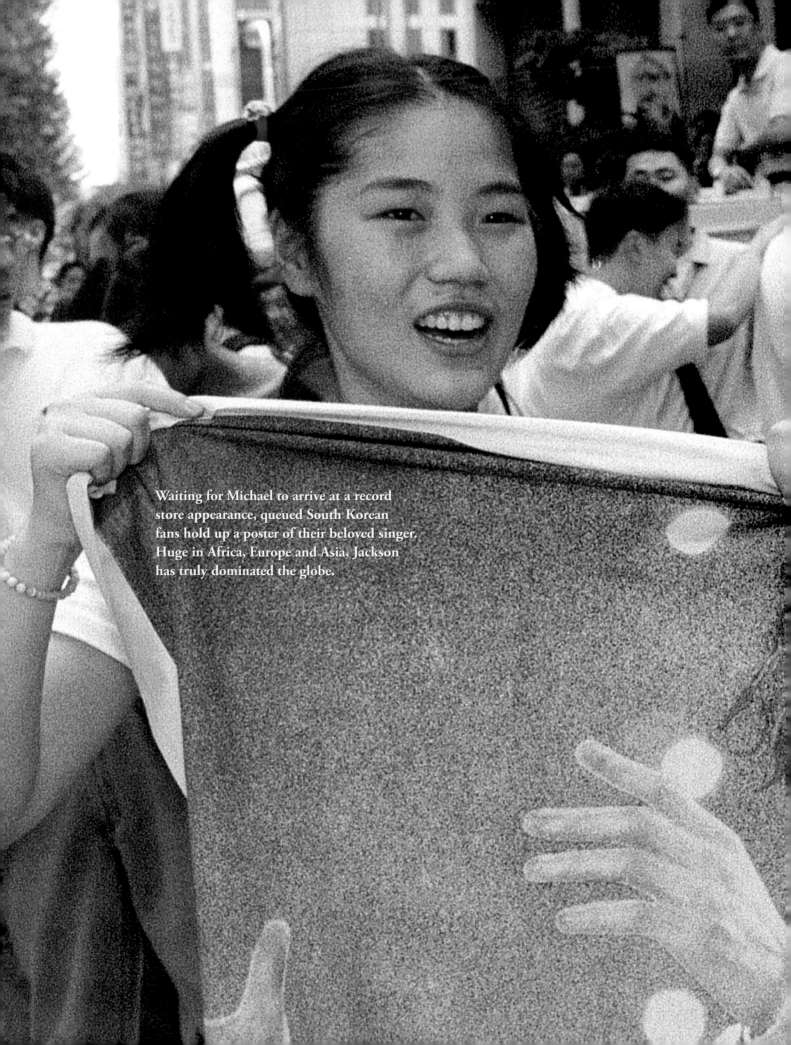

Waiting for Michael to arrive at a record store appearance, queued South Korean fans hold up a poster of their beloved singer. Huge in Africa, Europe and Asia, Jackson has truly dominated the globe.

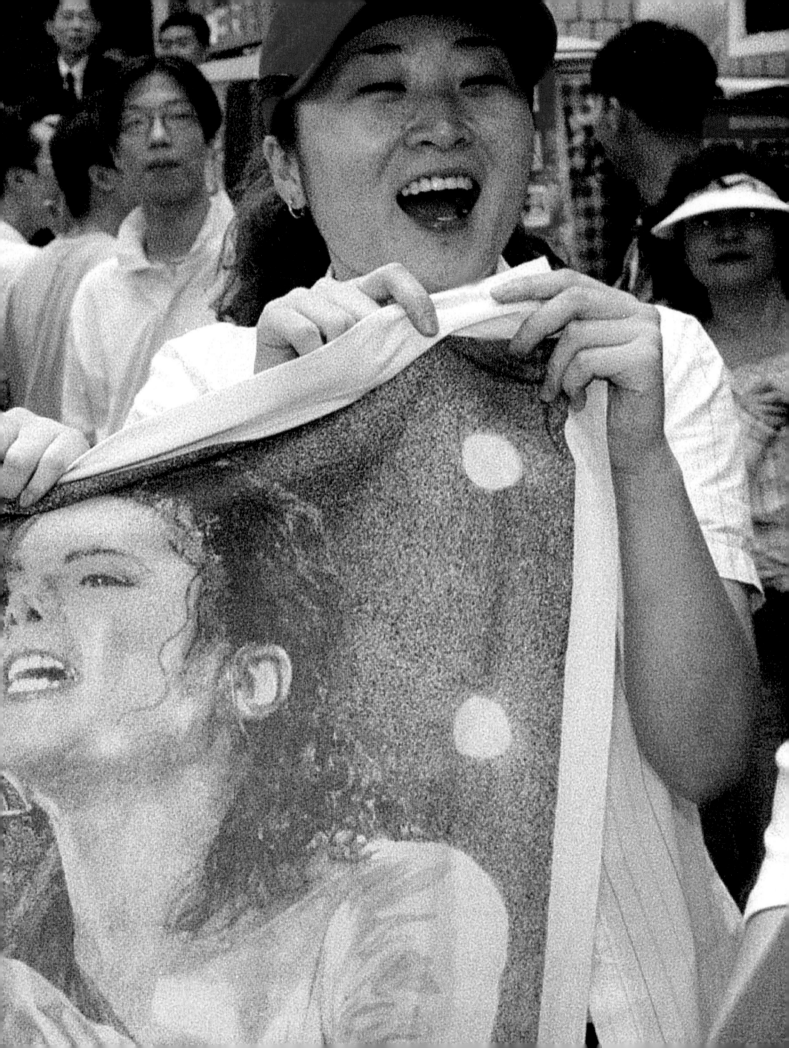

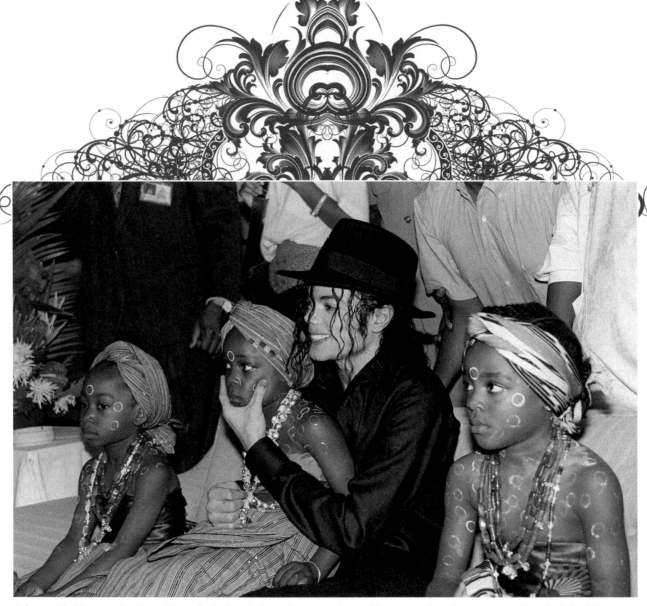

(above) Children in the Ivory Coast flocked to Jackson during a charitable visit to the African nation. The kids had been orphaned, so Michael took up their cause and held a press conference to bring awareness their plight.

(opposite) The King of Pop did not become the King by resting on his laurels. He was always innovative in his stage show, and the tour to back Dangerous was no different. A jetpack carried Jackson off the stage at each concert to the delight of the fans. The tour covered 89 shows and all proceeds from the concerts were donated to charity.

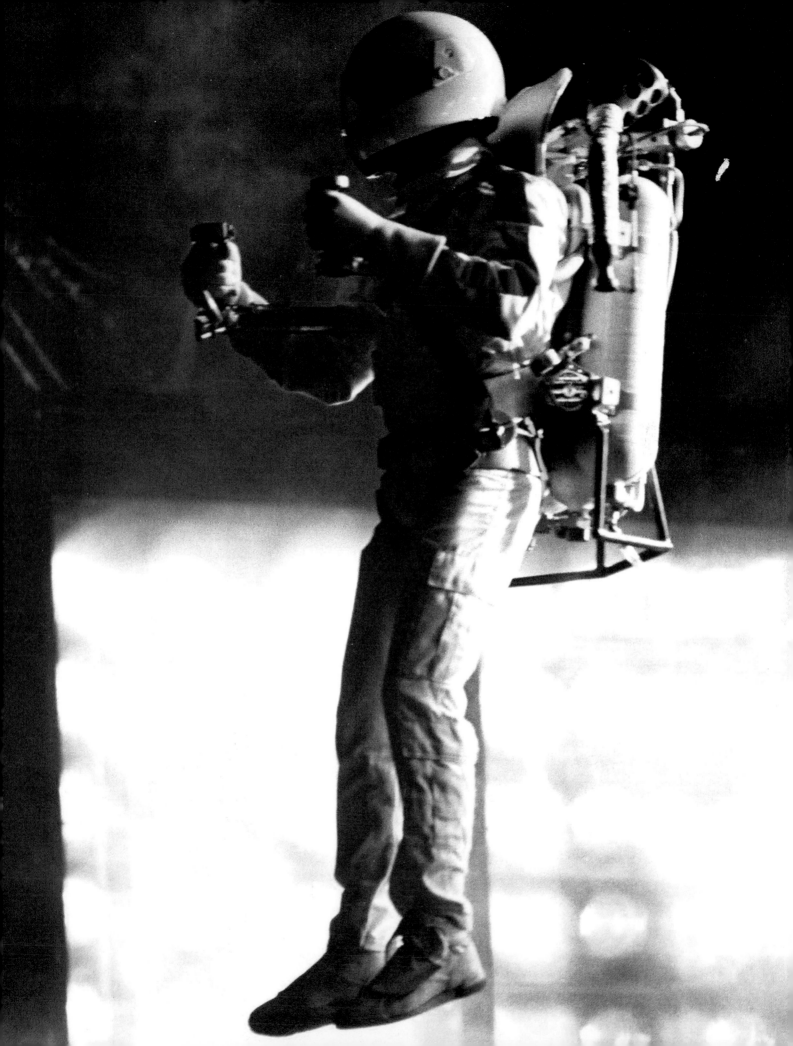

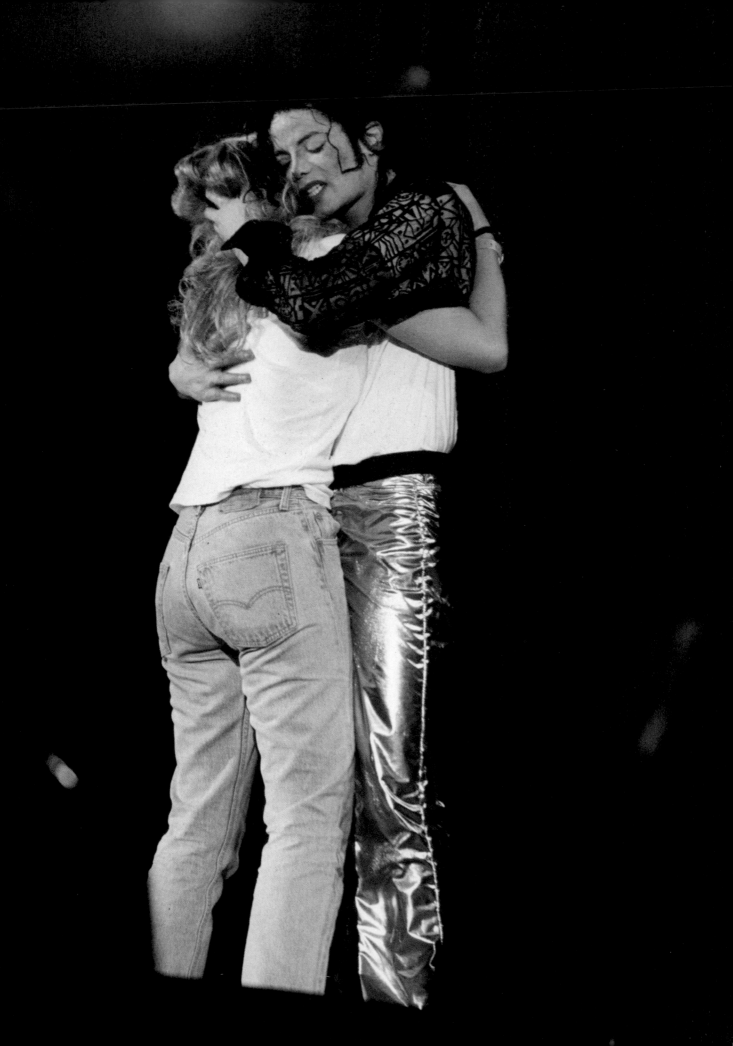

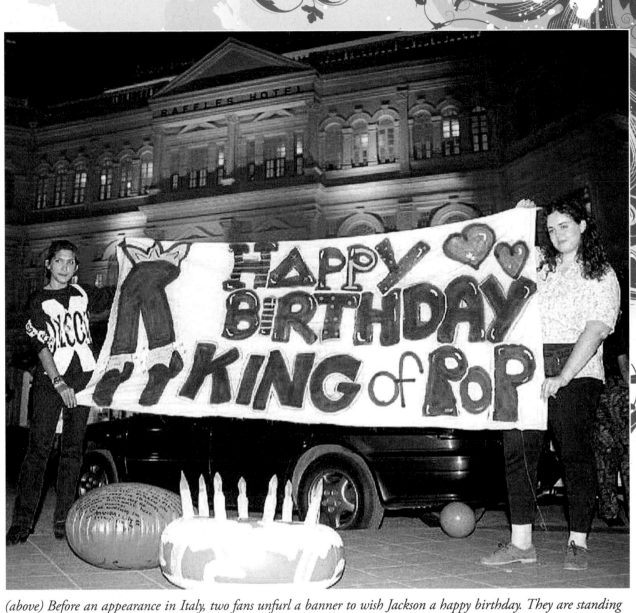

(above) Before an appearance in Italy, two fans unfurl a banner to wish Jackson a happy birthday. They are standing on the front steps of Jackson's hotel.

(opposite) A lucky fan shares a hug with Jackson onstage. Although shy and introverted by nature, Jackson always had a soft spot for his fans and those less fortunate than he was. His charitable work and kind nature will be remembered by everyone he knew.

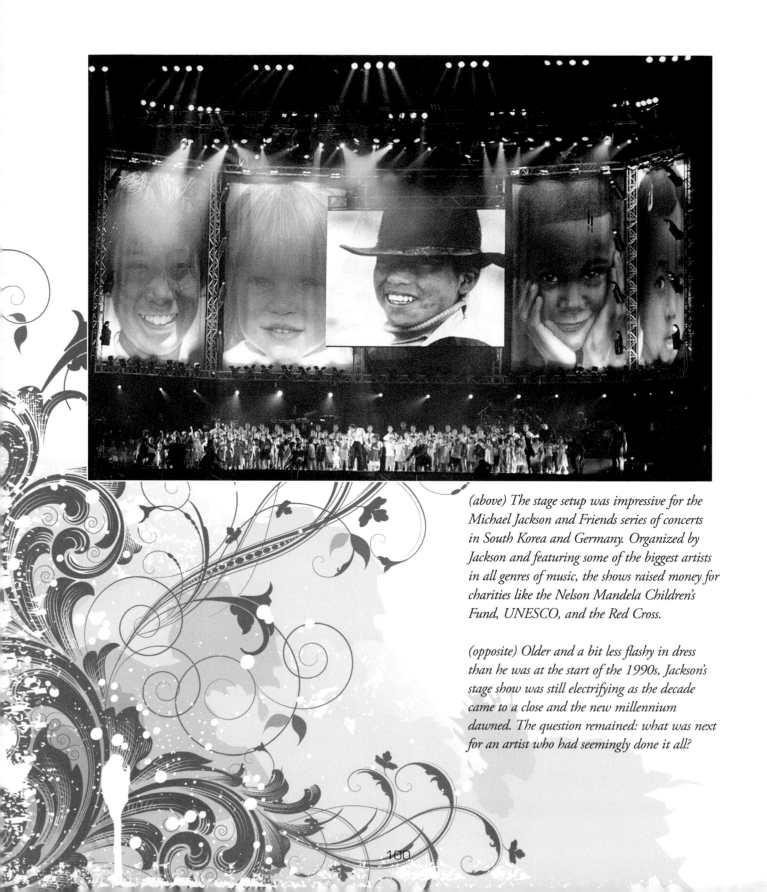

(above) The stage setup was impressive for the Michael Jackson and Friends series of concerts in South Korea and Germany. Organized by Jackson and featuring some of the biggest artists in all genres of music, the shows raised money for charities like the Nelson Mandela Children's Fund, UNESCO, and the Red Cross.

(opposite) Older and a bit less flashy in dress than he was at the start of the 1990s, Jackson's stage show was still electrifying as the decade came to a close and the new millennium dawned. The question remained: what was next for an artist who had seemingly done it all?

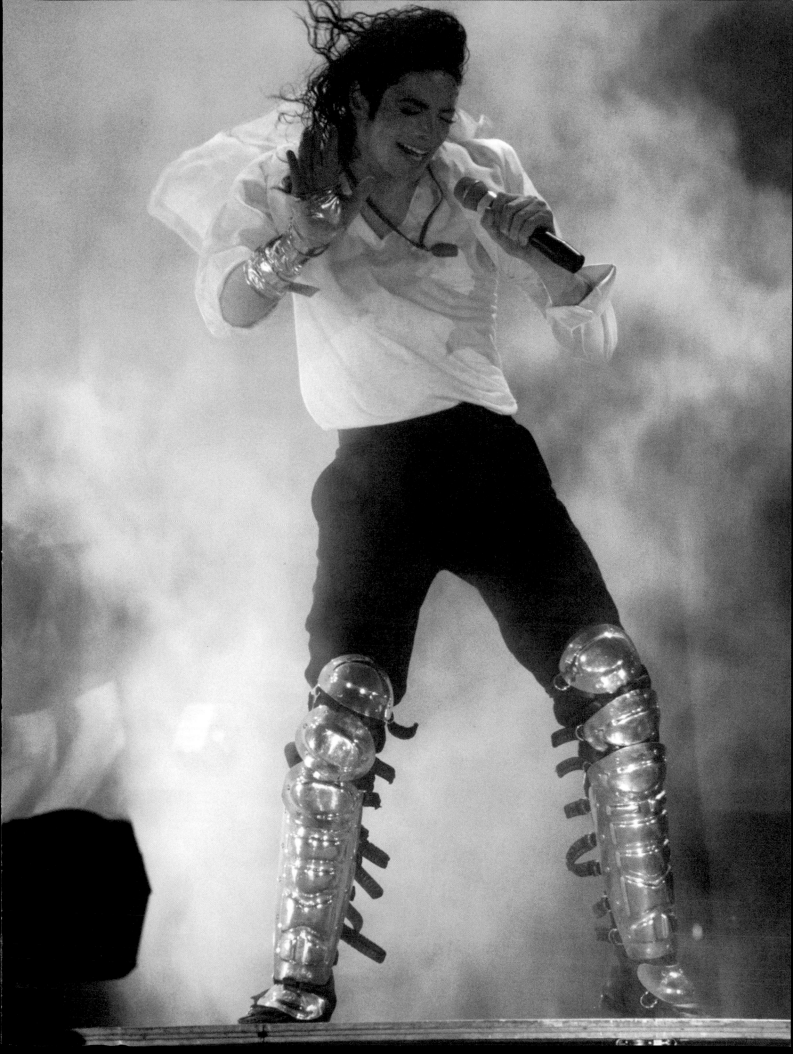

His Life in the 2000s

Jackson kicked off the new millennium with a bang, performing at the World Music Awards in Monte Carlo in March 2000.

As the 2000s began, the King of Pop was drifting off the mainstream entertainment radar. He had not released an album in several years and it seemed like he was beginning to fade into obscurity.

But he dove into his music and recorded his final album for Sony, *Invincible*. His first studio album since *HIStory*, *Invincible* was expected to challenge for the number-one spot on the Billboard 200 in its first week. Though he was going up against two of the biggest stars of the early part of the decade in Enrique Iglesias and the Backstreet Boys, Jackson ran laps around them, claiming the number-one spot in the United States by more than 100,000 albums. *Invincible* also topped the charts in 12 other countries, and to date has sold more than 10 million copies worldwide.

That the album sold so well is amazing. Due to a contract dispute with Sony and Jackson's imminent departure, the label refused to make videos for the album's singles and otherwise promoted the

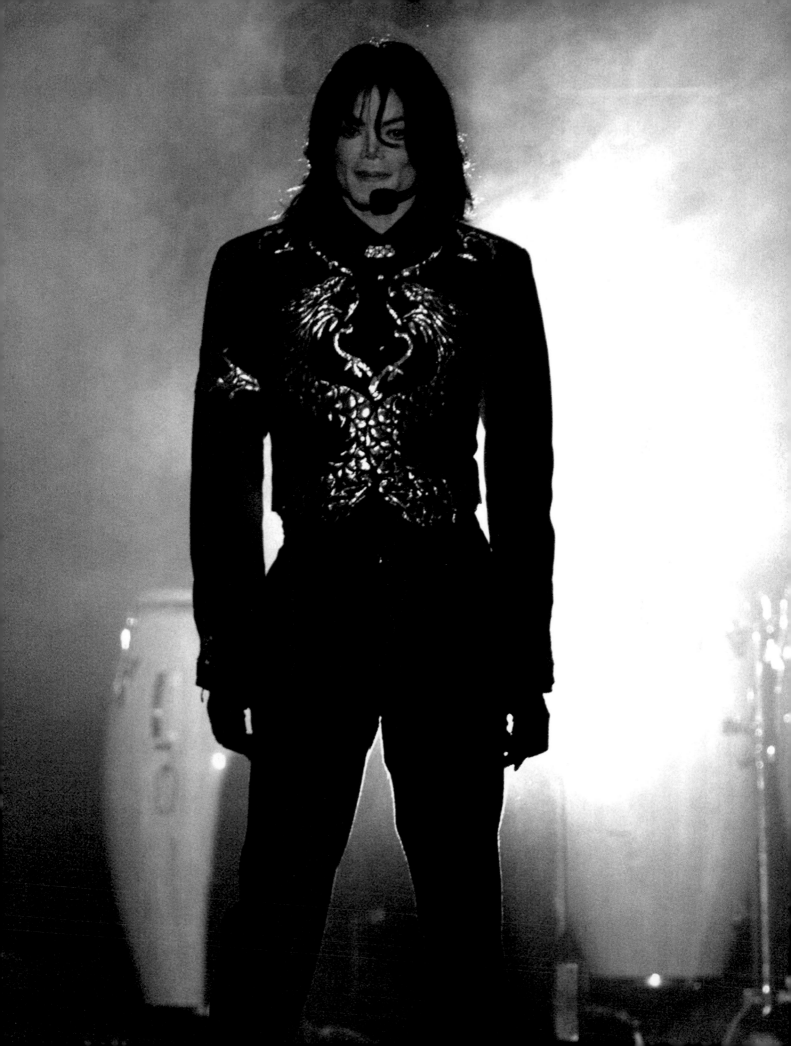

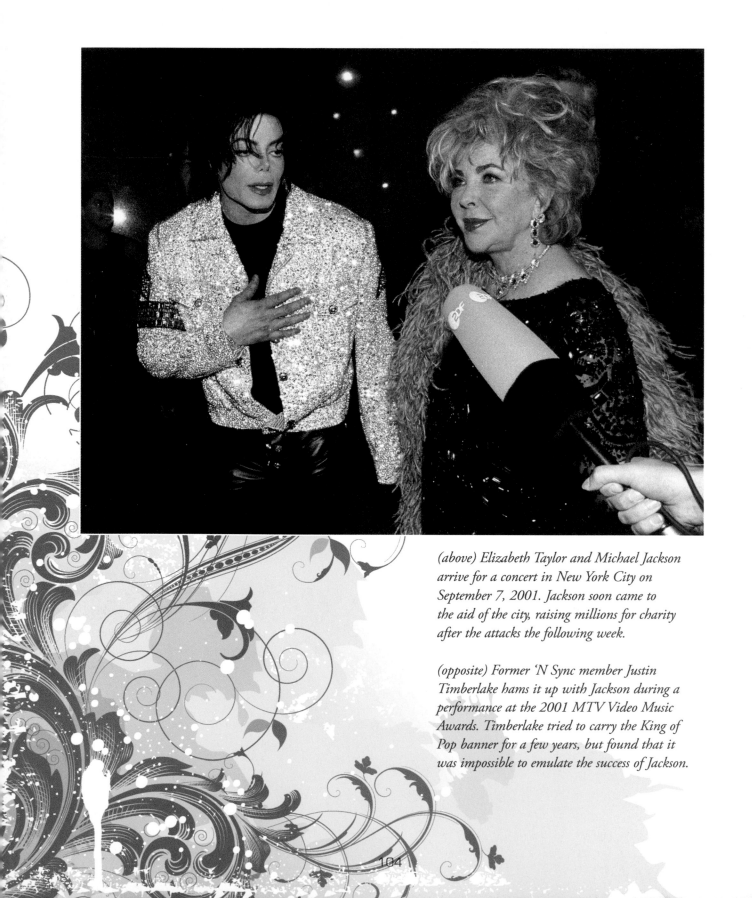

(above) *Elizabeth Taylor and Michael Jackson arrive for a concert in New York City on September 7, 2001. Jackson soon came to the aid of the city, raising millions for charity after the attacks the following week.*

(opposite) *Former 'N Sync member Justin Timberlake hams it up with Jackson during a performance at the 2001 MTV Video Music Awards. Timberlake tried to carry the King of Pop banner for a few years, but found that it was impossible to emulate the success of Jackson.*

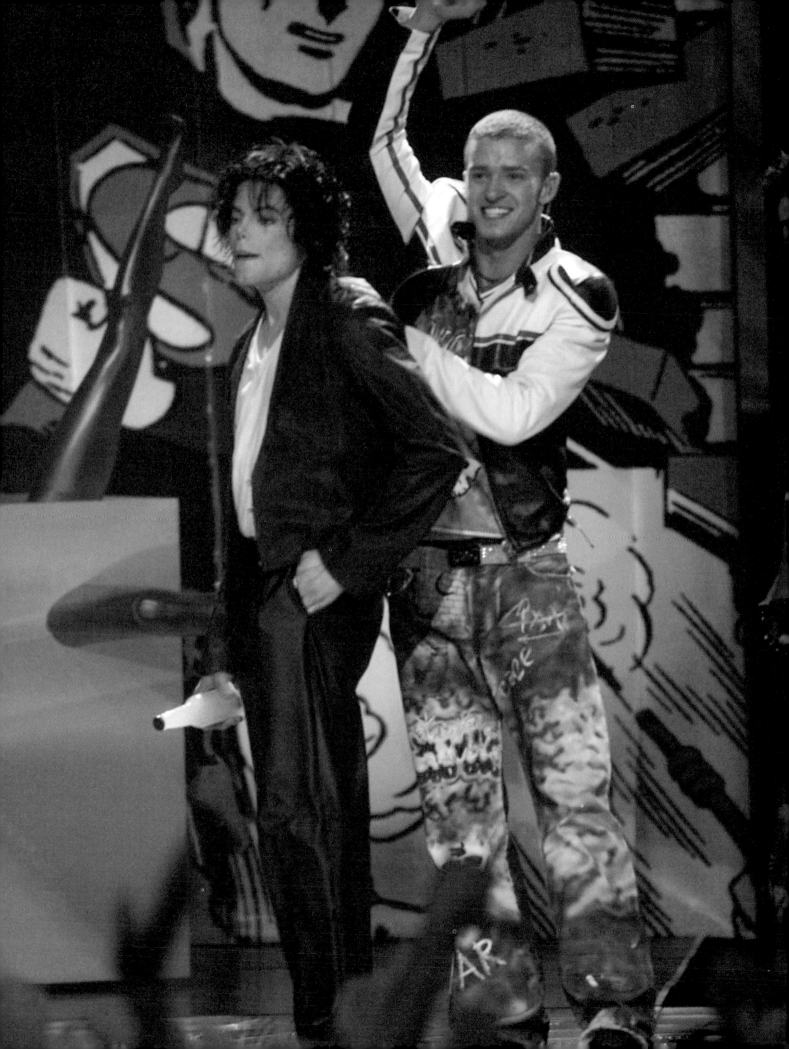

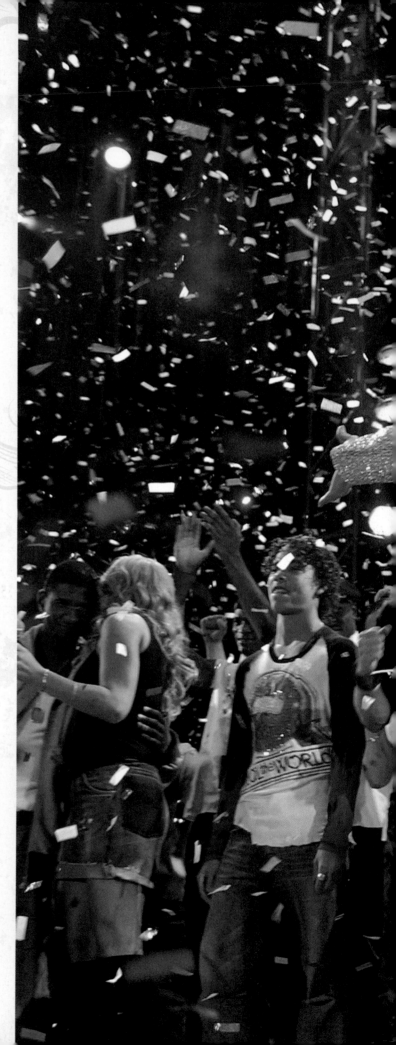

record very lightly. Music industry profits were diminishing with the advent of digital downloads, but Jackson proved once again that he was still the King of Pop.

Jackson's life took a turn into the truly bizarre when criminal charges were leveled against him in 2003. He didn't go on trial for two years, and after the soul-draining ordeal and media circus, Jackson was acquitted. He was vindicated in the eyes of his fans, who cheered outside the courthouse and around the world when the verdict was handed down.

The long battle had taken its toll physically and emotionally on Jackson, and despite the acquittal, many said he was never the same. He kept a low public profile for the next year, only emerging in 2006 to accept awards from the people at Guinness World Records, who awarded him for his dominance of the music industry.

Jackson may not have been making his own music for several years, but his music publication work continued to grow in scope. Partnering with Sony, Jackson scooped up rights to talented new artists like Eminem, Shakira, and Beck.

As the singer's 50th birthday neared, Sony BMG allowed Jackson's fans to have a say on their next release for the singer, *King of Pop*. Though not released in the United States, the concept proved massively popular—

The stirring finale of the United We Stand concert in October 2001. Jackson brought in some of the biggest names in entertainment, including Usher and Mariah Carey, to put on a legendary show that helped lift up the nation in the aftermath of September 11.

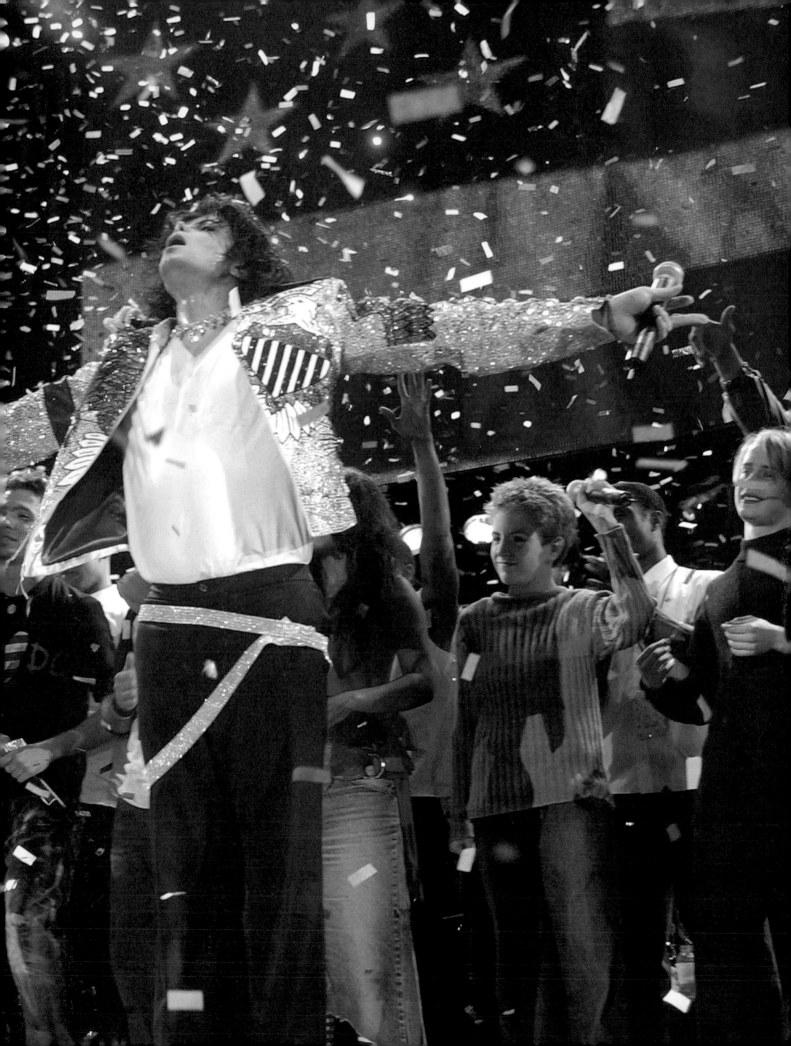

fans from each country where the album was released voted on what songs to include and in what order.

The success of the compilation and *Thriller 25,* a re-release from 2008, made concert promoter AEG realize that Jackson was still a viable live act. They booked Jackson for 50 shows at London's O2 Arena in 2009 and 2010 in a deal that could have earned more than $100 million for Jackson.

At first, Jackson seemed unsure about whether or not he was ready for the shows, even dubbing it his "This is It" tour and hinting at a possible retirement from music when he was done. But in 2009 it had become clear that Jackson's passion for making music was returning—he teased about working on a new album, a movie based on *Thriller,* and even going back out on a world tour. What Jackson might have accomplished with this new burst of creative energy, the world will never know. ★

James Brown takes a moment to pose with Jackson at the 2003 BET Music Awards. Jackson was hard-hit by Brown's death in 2006, one of his last moments in the public spotlight before his own death. The 2009 awards were just three days after Jackson's death, and his father and sister attended the show; Janet delivered an emotional message from her family thanking the world for their support.

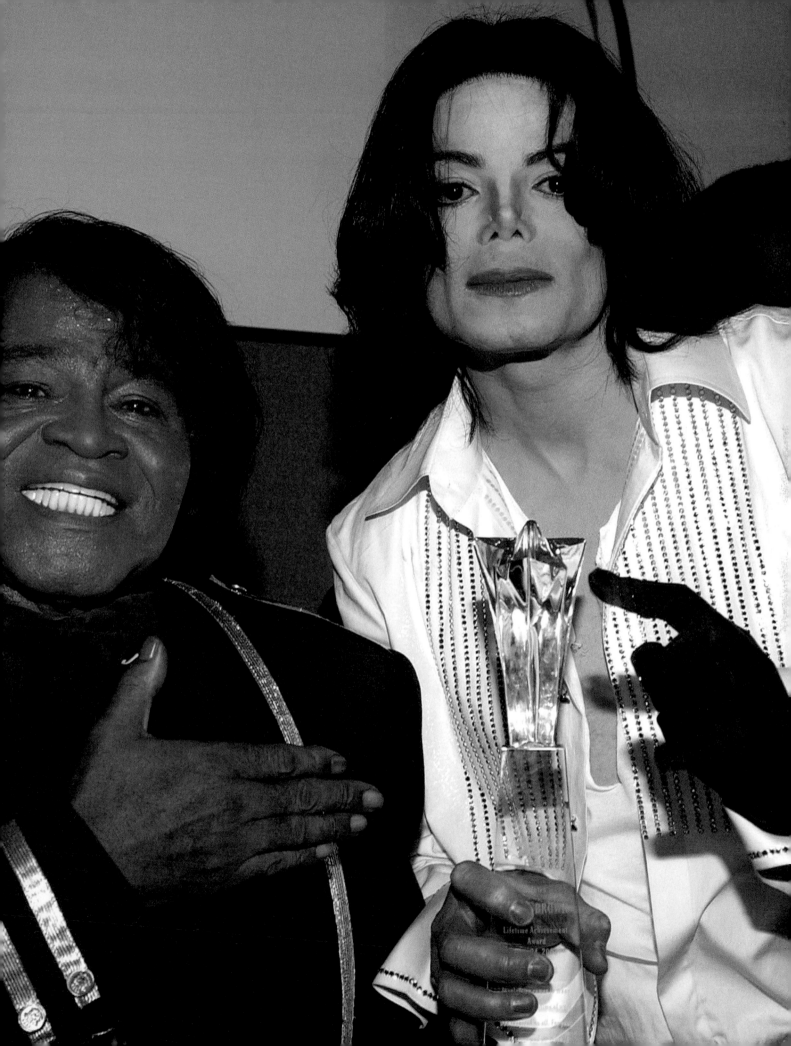

Friends & Family SHARE THEIR GRIEF

"I am so very sad and confused with every emotion possible. I am heartbroken for his children, who I know were everything to him, and for his family. This is such a massive loss on so many levels, words fail me."

— **Lisa Marie Presley** —

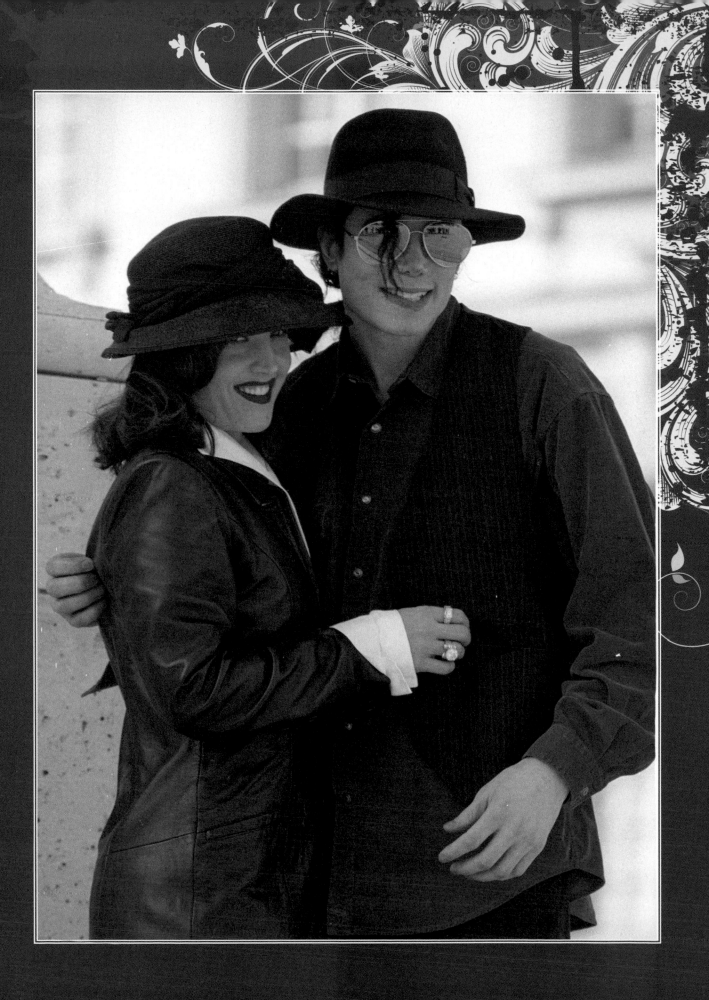

"I am deeply saddened to hear of Michael's sudden passing. His was a rare talent that we witness once in a lifetime—one who makes such an indelible mark that for generations singers and dancers attribute him as inspiration. I had the great privilege of watching him every night doing what he did best...entertain. I am grateful to have known him for the two years I worked for him and will mourn his loss with his many millions of fans across the world."

— Sheryl Crow —

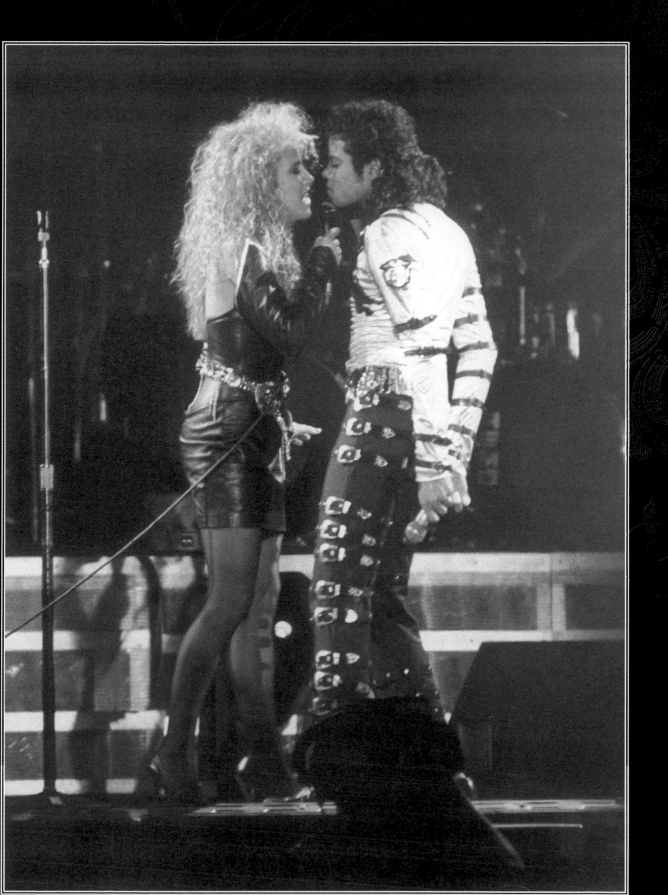

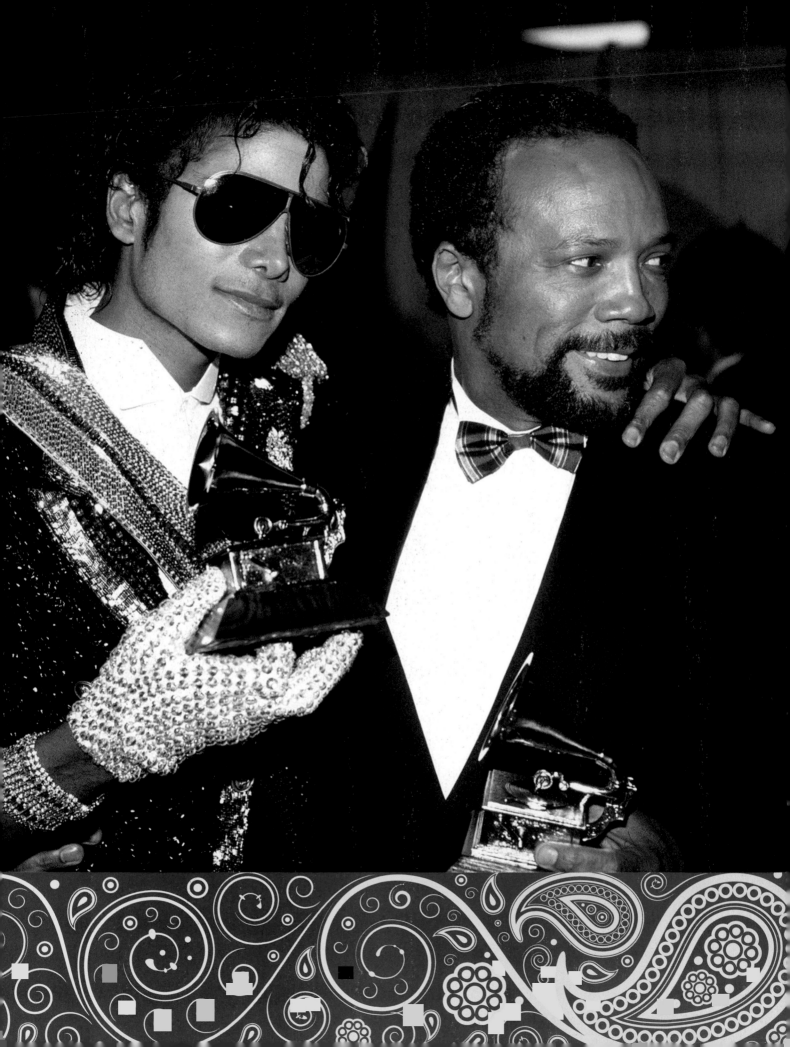

"For Michael to be taken away from us so suddenly at such a young age, I just don't have the words. To this day, the music we created together on Off the Wall, Thriller *and* Bad *is played in every corner of the world and the reason for that is because he had it all...talent, grace, professionalism, and dedication. He was the consummate entertainer and his contributions and legacy will be felt upon the world forever. I've lost my little brother today, and part of my soul has gone with him."*

— Quincy Jones —

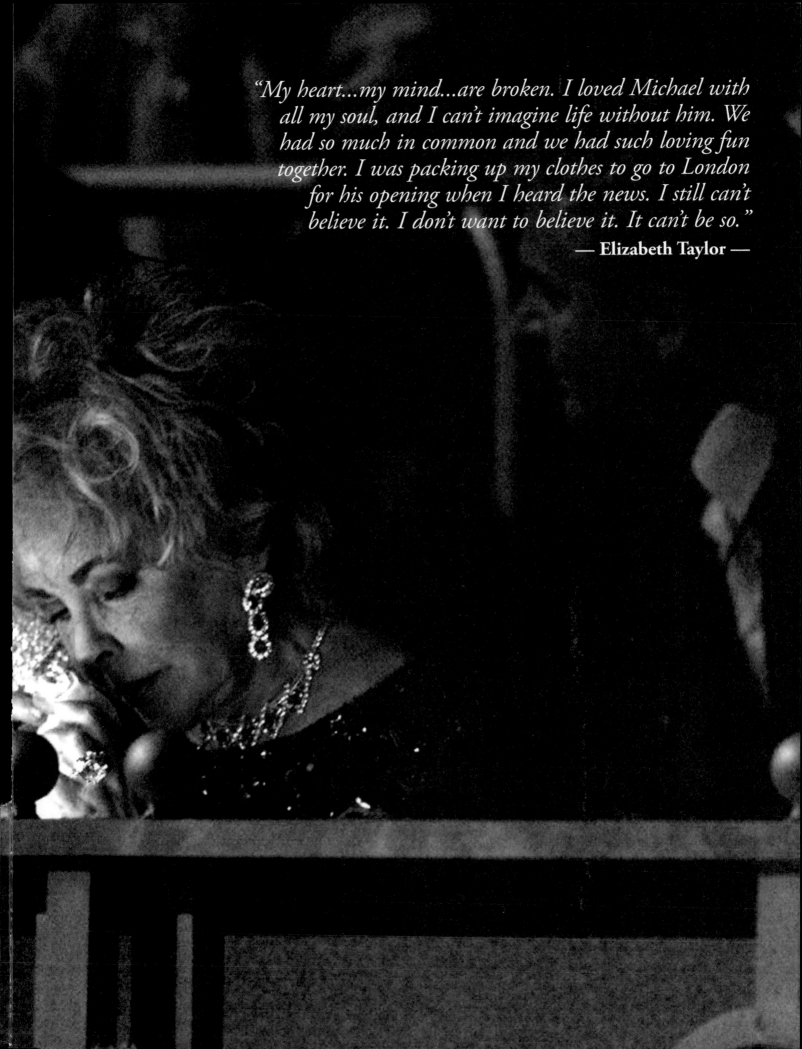

"My heart...my mind...are broken. I loved Michael with all my soul, and I can't imagine life without him. We had so much in common and we had such loving fun together. I was packing up my clothes to go to London for his opening when I heard the news. I still can't believe it. I don't want to believe it. It can't be so."

— **Elizabeth Taylor** —

"This loss has deeply saddened me; with a heavy heart I composed this statement. May God cover you, Michael. We all lift your name up in prayer. I pray for the entire Jackson family, particularly Michael's mother and all his fans that loved him so much. I would not be the artist, performer, and philanthropist I am today without the influence of Michael. I have great admiration and respect for him, and I'm so thankful I had the opportunity to meet and perform with such a great entertainer. In so many ways he transcended culture. He broke barriers, he changed radio formats! With music, he made it possible for people like Oprah Winfrey and Barack Obama to impact the mainstream world. His legacy is unparalleled. Michael Jackson will never be forgotten."

— Usher —

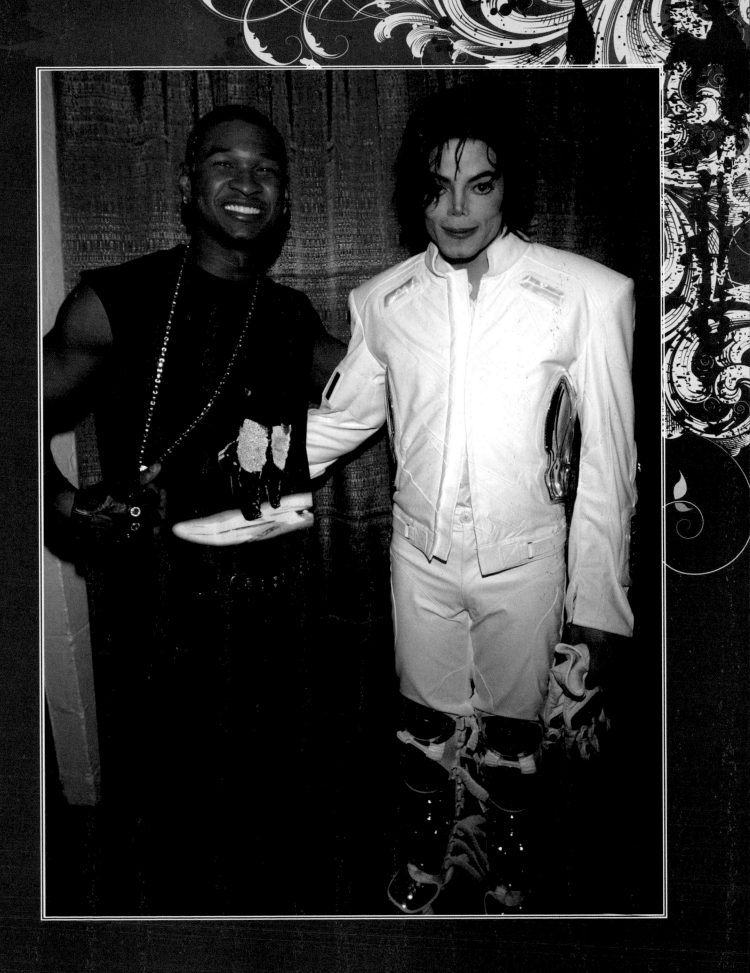

"*I can't stop crying over the sad news. I have always admired Michael Jackson. The world has lost one of the greats, but his music will live on forever! My heart goes out to his three children and other members of his family. God bless.*"

— **Madonna** —

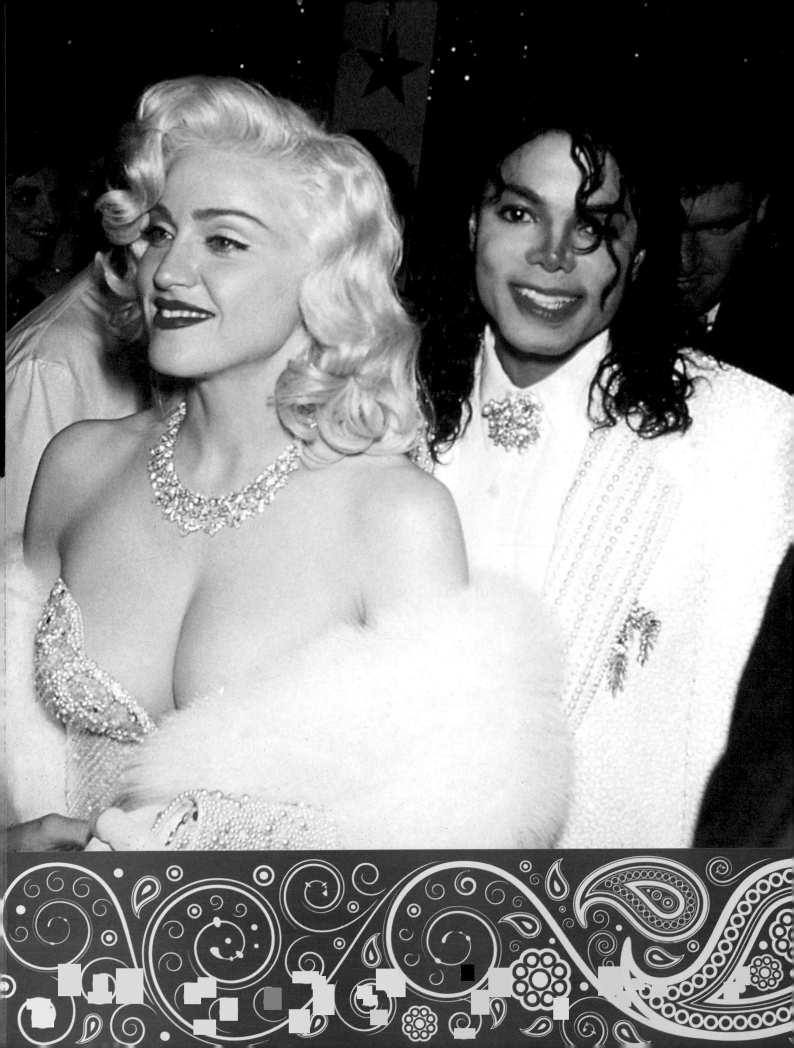

"My prayers go out to the Jackson family, and my heart goes out to his children. Let us remember him for his unparalleled contribution to the world of music, his generosity of spirit in his quest to heal the world, and the joy he brought to his millions of devoted fans throughout the world."
— **Mariah Carey** —

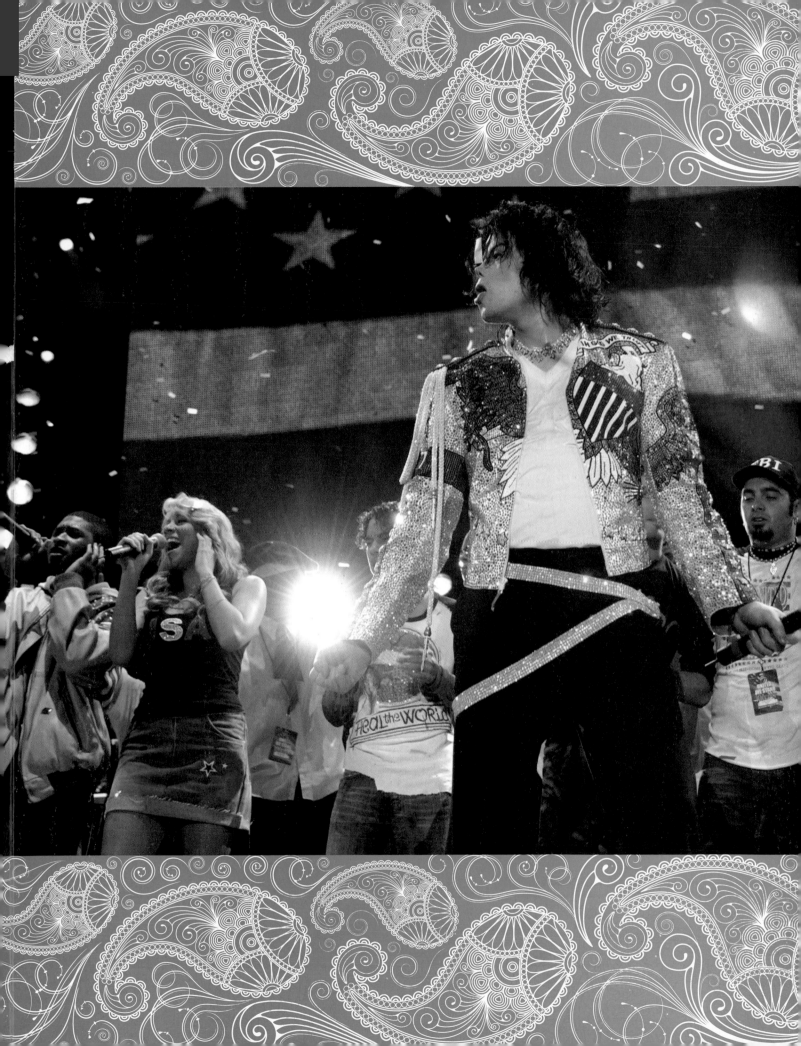

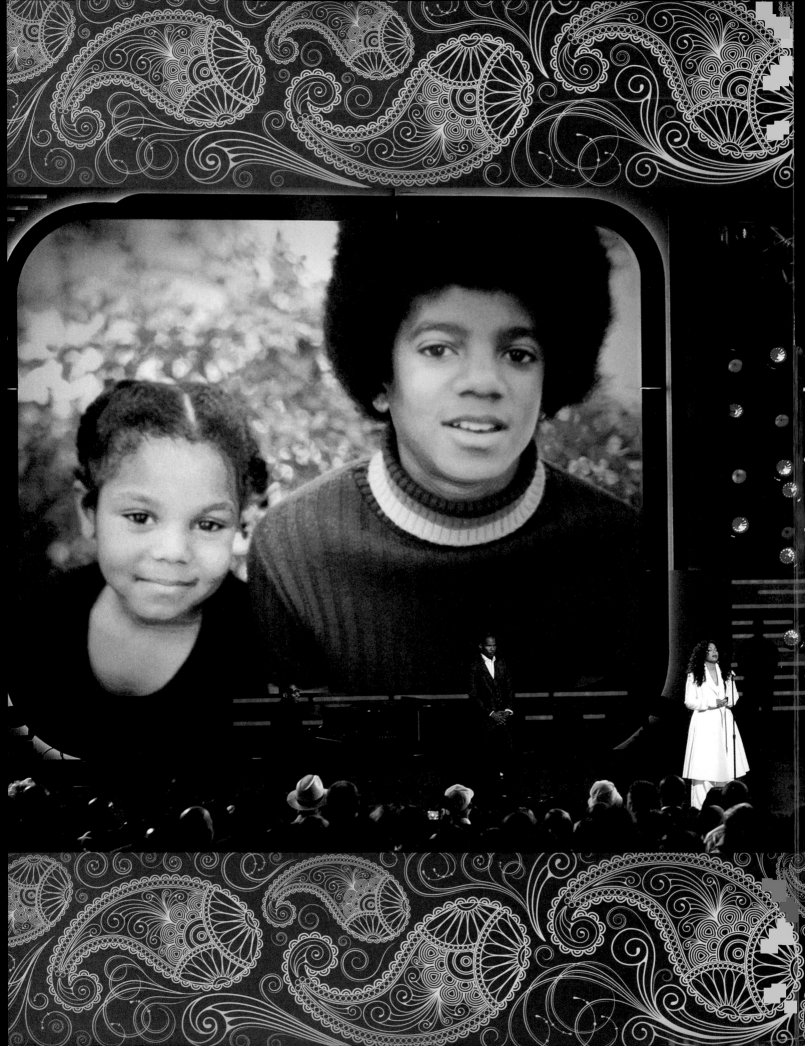

"*To you, Michael is an icon. To us, Michael is family. He will forever live in all of our hearts. On behalf of my family and myself, thank you for all of your love, thank you for all of your support. We miss him so much.*"

— Janet Jackson —
(at the BET Awards on June 28, 2009)

Discography

 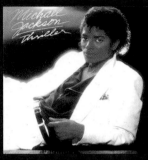

Got to Be There • 1972

Ben • 1972

Music & Me • 1973

Forever, Michael • 1975

Off the Wall • 1979

Thriller • 1982

Bad • 1987

Dangerous • 1991

HIStory: Past, Present and Future, Book 1 • 1995

Invincible • 2001

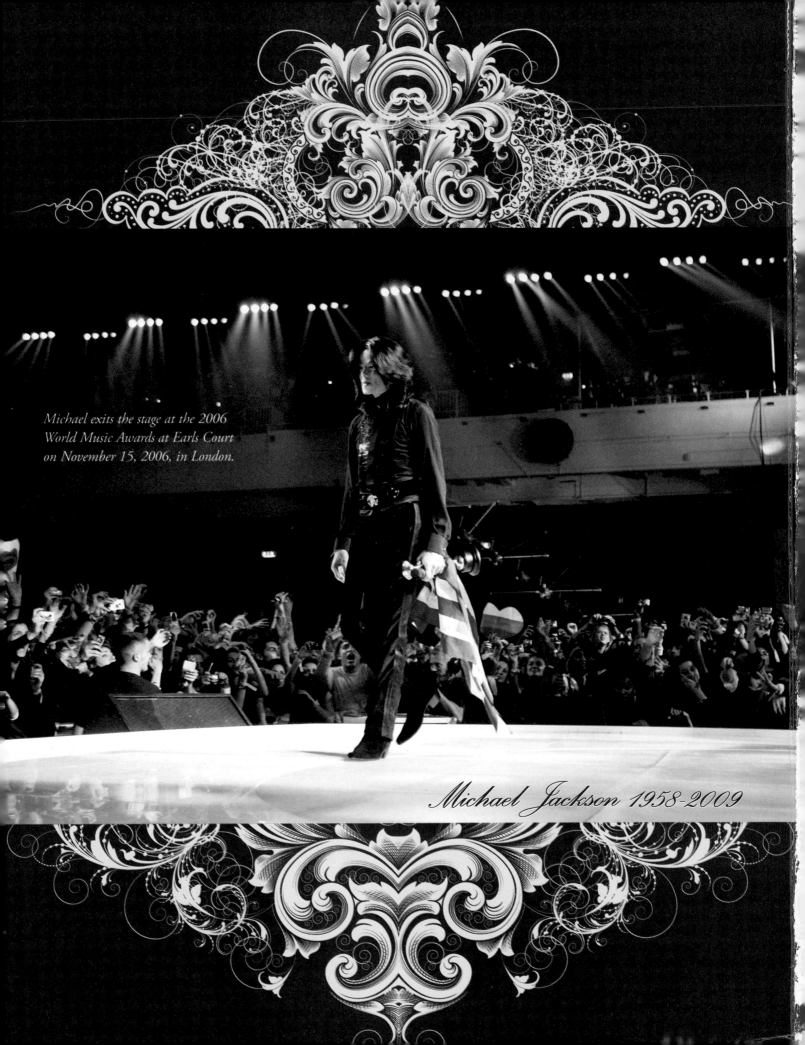

Michael exits the stage at the 2006
World Music Awards at Earls Court
on November 15, 2006, in London.

Michael Jackson 1958-2009